S0-ADB-349

9-24
STRAND PRICE
5.00

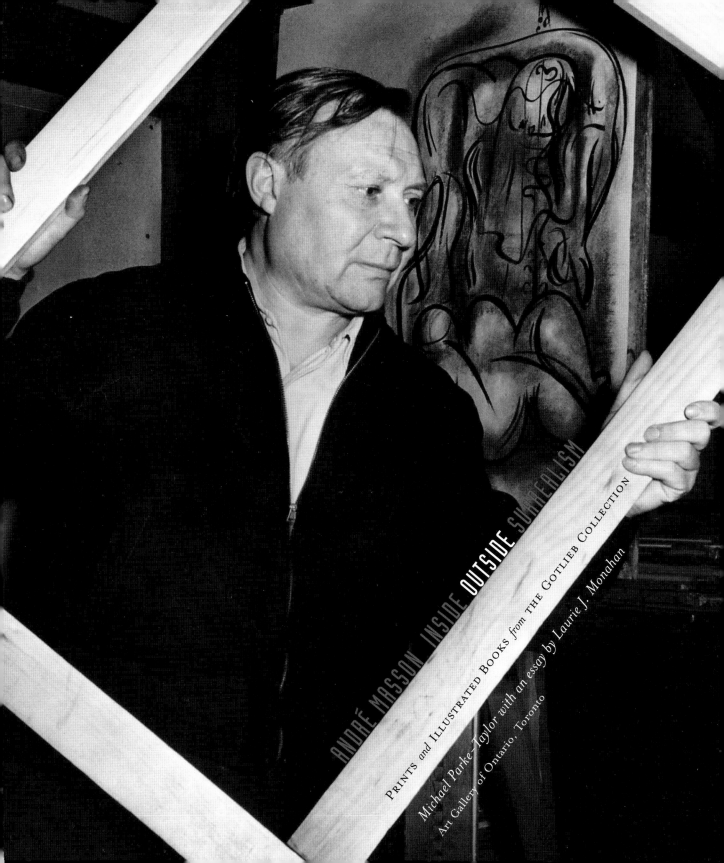

# ANDRÉ MASSON INSIDE OUTSIDE SURREALISM

Prints and Illustrated Books from the Gotlieb Collection

Michael Parke-Taylor with an essay by Laurie J. Monahan

Art Gallery of Ontario, Toronto

"THE BEGINNING AND THE END ARE COMMON ON THE CIRCUMFERENCE OF THE CIRCLE."

~HERACLITUS

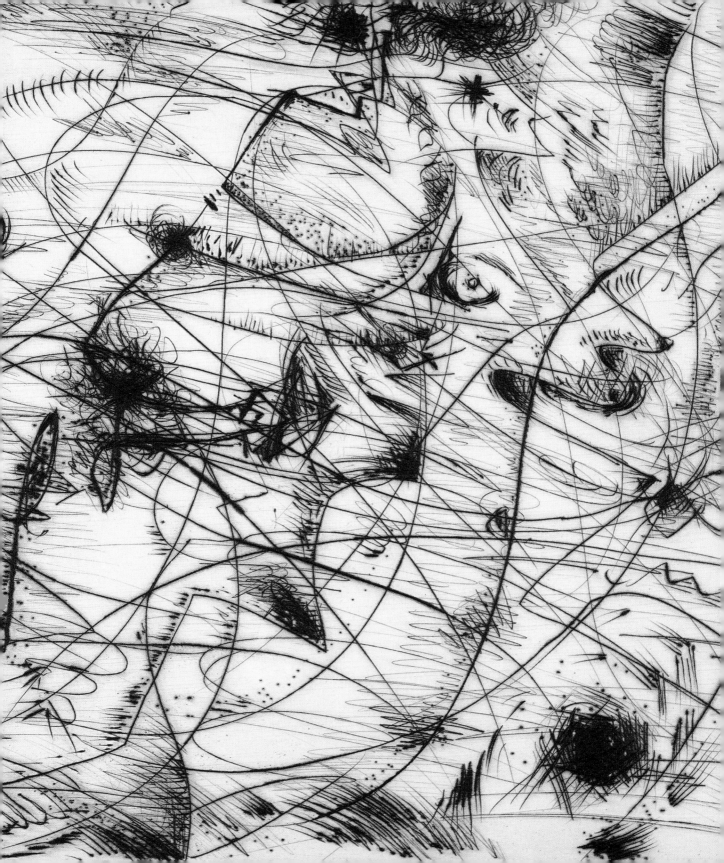

COPYRIGHT © 2001 Art Gallery of Ontario

All rights reserved. No part of this book may be
reproduced, transmitted in any form or by any
means, electronic, mechanical, photocopying,
recording, or otherwise, or stored in a retrieval
system, without written permission from the
publisher (or in the case of photocopying or
other reprographic copying, a licence from a
licensing body such as the Canadian Copyright
Licensing Agency), except by a reviewer, who
may quote brief passages in a review.

Printed and bound in Canada

NATIONAL LIBRARY OF CANADA
CATALOGUING IN PUBLICATION DATA

Parke-Taylor, Michael
  André Masson inside/outside surrealism: prints
and illustrated books from the Gotlieb Collection

Catalogue of an exhibition held at the McMullen
Museum of Art, Boston College, 28 Jan.–28 Apr.,
2002, and the Art Gallery of Ontario,
14 June – 8 Sept., 2002.
Includes bibliographical references.

ISBN 1-894243-15-3

I. Masson, André, 1896–1987—Exhibitions.  I.
Monahan, Laurie Jean, 1959–  II. Art Gallery of
Ontario. III. McMullen Museum of Art. IV. Title.

NC980.5.M34A4 200  769.92  C2001-902448-7

The Art Gallery of Ontario is funded by the Ontario Ministry of Tourism,
Culture and Recreation. Additional operating support is received from
the Volunteers of the Art Gallery of Ontario, the City of Toronto, the
Department of Canadian Heritage and the Canada Council for the Arts.

**Art Gallery of Ontario**
317 Dundas Street West
Toronto, Ontario, Canada
M5T 1G4  www.ago.net

ITINERARY

McMullen Museum of Art, Boston College
28 January – 28 April 2002

Art Gallery of Ontario
14 June – 8 September 2002

SOURCES AND PHOTO CREDITS

All photographs by Carlo Catenazzi and Sean
Weaver except for photos on frontispiece and
pp. 19, 30, 34, 42, 50, 53, 79, 96, which are
courtesy of Comité André Masson. Photograph
on pp. 19 and 42 by Robert Doisneau.

ANDRÉ MASSON: Reproduction of artwork by
André Masson © Estate of André Masson/ADAGP
(Paris)/SODRAC (Montréal) 2001

JOAN MIRÒ: © Successiò Mirò/ADAGP
(Paris)/SODRAC (Montréal) 2001

YVES TANGUY: © Estate of Yves Tanguy/ARS
(New York)/SODRAC (Montréal) 2001

FRONT COVER
33. *Improvisation,* 1945
Engraving and aquatint on wove paper
19.8 x 14.9 cm (plate)
32.0 x 25.2 cm (sheet)

FRONTISPIECE
André Masson in his studio,
New Preston, Connecticut, c.1944

PAGE 3
44. *Rapt* (detail), 1941? 1946?
Drypoint on Japon ancien wove paper
30.8 x 40.6 cm (image)
50.1 x 66.5 cm (sheet)

EDITOR
Catherine van Baren

GRAPHIC DESIGN
Evelina Petrauskas

TYPOGRAPHY
Mrs. Eaves, Industria

PRINTING
St. Joseph/MOM

# TABLE OF CONTENTS

# FOREWORD

OVER THE PAST FOUR DECADES, ALLAN GOTLIEB, former Canadian ambassador to the United States, collected prints and illustrated books by the French Surrealist André Masson (1896–1987) and prints by the Victorian painter and etcher James Tissot (1836–1902). He brought passion, patience and scholarship to his collecting. In 1994–95 Mr. Gotlieb and his wife, Sondra, donated their collection of 114 Tissot prints to the Art Gallery of Ontario. In 1999 the Gotliebs gave their entire collection of 93 prints and illustrated books by Masson to the Art Gallery of Ontario. In addition Mr. Gotlieb presented his considerable Masson library to the AGO's Edward P. Taylor Research Library and Archives. It gives us great pleasure to exhibit *André Masson inside/outside Surrealism* as a celebration of this generosity.

Mr. Gotlieb's attention was first directed to Masson as early as 1963, when he visited an exhibition in Geneva – five years before he started to collect works by Tissot. Over subsequent decades, Mr. Gotlieb painstakingly sought and acquired virtually every major print and illustrated book by Masson. Mr. Gotlieb's adventure as a collector is revealed in an interview published in this catalogue and conducted by the curator of the exhibition, Michael Parke-Taylor, who is associate curator of European Art.

The Gotlieb gift encompasses all aspects of Masson's printed oeuvre, which was created over half a century of artistic activity. In the following pages Michael Parke-Taylor gives an overview of Masson's printmaking career "inside" and "outside" Surrealism. Laurie J. Monahan, assistant professor of Art History at the University of California, Santa Barbara, contributes an insightful study of Masson's work during the 1930s, a high point in the artist's print career marked by the publication of the 1936 portfolio of sanguine etchings entitled *Sacrifices*.

The authors would like to thank Diego Masson, Guite Masson and the Comité André Masson in addition to the following people who have contributed in numerous ways to the catalogue and exhibition: David Acton, Barbara Butts, Susan Dackerman, Jay Fisher, William Jeffett, Peter Nisbet and Douglas Shawn. For their support during his research, Michael Parke-Taylor would like to thank the staff of the Getty Research Institute and the Drawings Department at the J. Paul Getty Museum. Special thanks is owed to Lawrence Saphire, author of the Masson graphic oeuvre catalogues, who provided invaluable information and sage advice. Helen Melling, executive administrative assistant to Mr. Gotlieb at Stikeman Elliott helped in numerous ways. Finally I should like to thank Nancy Netzer, director of the McMullen Museum of Art, Boston College, for her support. We are delighted to open this exhibition at her institution.

Exhibitions are very much the product of collaborative enterprise, and at the Art Gallery of Ontario I would like to thank the following individuals for their exceptional contributions to this project: Dennis Reid, chief curator; Iain Hoadley, manager, Exhibitions and Travelling Exhibitions; Marcie Lawrence, Travelling Exhibitions coordinator; Wendy Hebditch, administrative assistant, European Art Department; Catherine van Baren, editor; Lauren Hamlin-Douglas, assistant editor; Lucie Chevalier, French Language Services coordinator; Sherri Somerville, assistant manager, Design Studio; Karen Sung, production assistant, Design Studio; Syvalya Elchen, copyright administration; Faye Van Horne, Photographic Resources coordinator; Carlo Catenazzi, head photographer, and Sean Weaver, photographer, Photographic Resources; Evelina Petrauskas, graphic designer, Design Studio; Jim Bourke, project designer, Exhibition Services; Larry Pfaff, deputy librarian, Library and Archives; John O'Neill, works on paper conservator; Ralph Ingleton, conservation assistant - technical, Conservation Department; Barry Simpson, registrar; Curtis Strilchuk, exhibitions registrar; and Myron Jones, installation coordinator; George Bartosik, manager; Charles Kettle, production coordinator; and Brian Groombridge, packing technician, all from Exhibition Services.

Masson remains one of the most misunderstood artists of twentieth-century Modernism, because his work is complex and challenging. This is exacerbated by the fact that his oeuvre is generally inaccessible and rarely seen in exhibition. The gift of the Gotlieb collection makes the AGO a unique public repository of a significant body of the artist's graphic work. Moreover, the gift complements the Gallery's holdings of Surrealist paintings, sculptures and works on paper by artists such as Miró, Matta, Magritte, Tanguy, Dali, Moore, Giacometti and Picasso, and provides a link to the large graphic holdings at the AGO of Robert Motherwell, whose Abstract Expressionism was rooted in Surrealism. We are delighted and grateful that the Gotliebs have seen fit to entrust their important collection to the Art Gallery of Ontario, where it will always be a valuable resource to further our understanding of the transforming talent of André Masson.

Matthew Teitelbaum
DIRECTOR, ART GALLERY OF ONTARIO

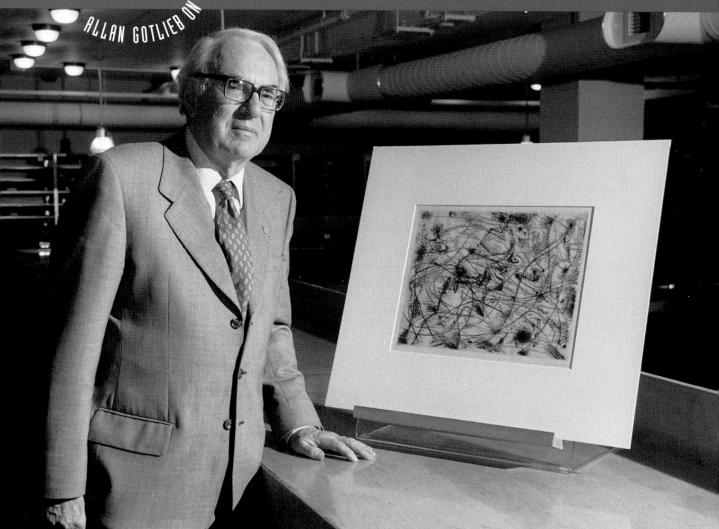

PASSION OF A COLLECTOR

ALLAN GOTLIEB ON ANDRÉ MASSON

*An association of the modernist artist André Masson (1896–1987) and the Victorian painter and etcher James Tissot (1836–1902) conjures something improbable. They seem an unlikely pair since Tissot is known for his nineteenth-century images of middle-class Paris and London, while Masson is associated with the first generation of twentieth-century Surrealists. Yet these two disparate French artists ignited a collecting passion in Allan Gotlieb some four decades ago. With scholarly dedication and infinite patience, Mr. Gotlieb assembled a comprehensive collection of their prints, comprised of only the finest impressions. In 1994–95 Mr. Gotlieb and his wife, Sondra, gave their collection of 114 etchings by James Tissot to the Art Gallery of Ontario. In 1999 they further enriched the Gallery with a donation of 93 prints and illustrated books by André Masson.*

*Allan Gotlieb was Canadian ambassador to the United States from 1981–89. From 1989 to 1994 he was chairman of the Canada Council. The following interview was conducted on 28 February 2000 and 20 February 2001 by Michael Parke-Taylor, associate curator of European Art at the Art Gallery of Ontario.*

### What is it about Surrealism that piqued your interest before you focused your collecting attention on André Masson?

As a child, my taste for fantasy and the supernatural was fuelled by the writings of Edgar Allan Poe (1809–1849), who is still one of my favourite authors. He represented something *otherworldly*, just as Masson was to create a parallel world in his Spanish landscapes of the 1930s. At one point I wanted to make a catalogue of works by artists such as Édouard Manet (1832–1883) and Odilon Redon (1840–1916), who illustrated Poe. It is the fantastic other world that one finds, for example, in the later works of James Tissot and Max Klinger (1857–1920) that has always attracted me.

### How did you become interested in the work of Masson?

I first saw Masson's work in 1962, while serving in the Canadian permanent mission to the United Nations in Geneva. Although Masson was highly regarded in France and Switzerland, his work was not well known. My initial encounter with Masson was at the Galerie Leandro. But I did not purchase anything at that time. In the summer of 1963 another gallery in Geneva mounted a Masson retrospective — Galerie du Perron [27 June – 31 August 1963]. The proprietor, Selim Benador, had run the gallery for many years. He presented wonderful exhibitions of paintings by Masson and at that time I purchased the

Allan Gotlieb with Masson's automatist drypoint *Rapt* (CAT. NO. 44), 28 February 2000

watercolour *La légende du maïs,* 1942 (cat. no. 22/fig. 1) and the painting *Le champ rouge,* 1934 (cat. no. 18/fig. 2). Mr. Benador was a very tough businessman. I really wanted *Le champ rouge,* which Masson made in Tossa de Mar in Spain while living there prior to the Civil War. The painting is a cauldron of insects running around a great red and yellow field. It cost something like 5,000 SF, but Mr. Benador wouldn't let me take it home on approval until I had paid off the last nickel.

Selim Benador was an unprepossessing man, but he regarded Masson as a more important artist than Miró in the Surrealist arena. There was something to that observation. One of the things that I discovered from Galerie du Perron's exhibition was Masson's radical changes in style. There was no signature style. I think that this has added to the recherché quality of the artist. Sometimes his work doesn't look like it should, or what you might expect it to look like.

Shortly thereafter I went to the gallery of Gérald Cramer, the prominent publisher and connoisseur. Cramer announced that he was having a show in the fall of 1963 entitled *Le monde imaginaire d'André Masson* (28 October – 6 December 1963) (fig. 3). At that point I had seen only a few of Masson's colour prints from the fifties. I had no idea what Cramer's exhibition would look like. I was bowled over! Most of the works in the show came from Galerie Louise Leiris in Paris, including prints from the forties and fifties. When I went into those rooms in the Galerie Gérald Cramer, I was shocked, because I was confronted with an imaginary world of turmoil, monsters, desires, dreams and change that I had never seen visualized.

I had already developed a taste for Surrealism in the early fifties while studying at Oxford. At that time my knowledge came from reproductions, specifically from books issued by the Swiss publisher Skira, which were very important for disseminating information about Modern art. I realized Surrealism had an electric appeal for me. Perhaps it was the sense of the bizarre or the exotic, but I was drawn to these dreamlike and strange images. When I saw Masson's work in Cramer's exhibition, I appreciated him as one of the few founding members of Surrealism. Masson's prints were not expensive by the standards at the time, and I bought four or five of them. After their acquisition, I dreamt of buying more. Cramer had produced a modest but rather informative exhibition catalogue. I read that catalogue over and over and had it memorized. I knew every comma in it. Cramer was a very good print and drawing dealer, and in 1965 he mounted an exhibition of drawing and sculpture by Masson from which I purchased the drawing *Trois métamorphoses* (cat. no. 21/fig. 4). I also continued to purchase prints from Cramer, since he had some Massons available every year.

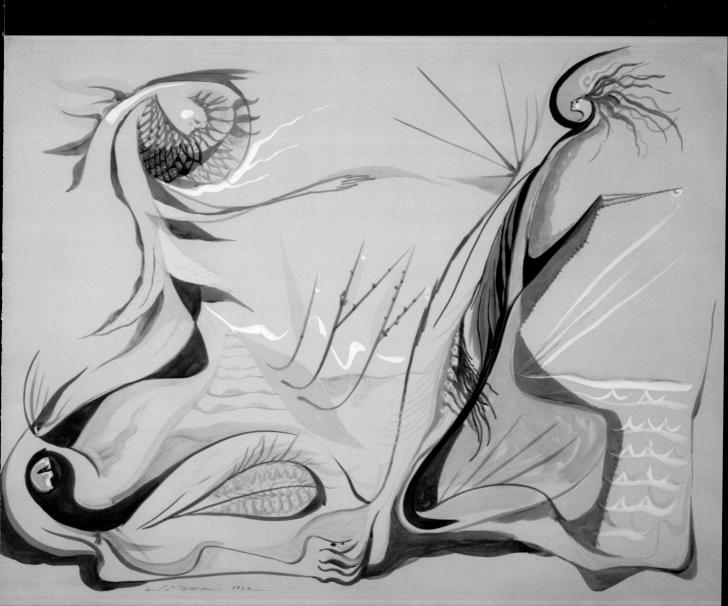

**What is it about Masson that commanded your attention?**

I absolutely loved the earliest period of Masson's creation, which was an extension of Analytic Cubism. He took what the late Cubists were doing and mixed it with a proto-Surrealist line. There are few painters who are able to draw a line that is so electric — so charged. That quality of line enabled Masson to achieve the fame he enjoys through his automatic drawings, with their explosive, fast moving lines. For the same reason I am attracted to *fin de siècle* Art Nouveau. Masson's work and Art Nouveau share movement, the arabesque, the curling line, and the ability to create a charged sense of excitement and emotion that to me represents an experience of sheer beauty. Masson's line captivated me, and I was as a result deeply attracted to him as an artist.

Another thing that appeals to me about Masson is the protean nature of the man — the tremendous experimentation, the massive shifts. I find it extraordinary that he could make the explosive automatic drawings and later do the outstanding book *Voyage à Venise*, 1952 (cat. no. 67 a-b/fig.21), which is perhaps the ultimate in harmony, like Mozart, exhibiting a sense of enormous peace and balance. This is not to say that I didn't suffer some disappointment in terms of Masson's evolution. Like a lot of other painters, Masson repeated himself a great deal and made a living through turning out a lot of things. He was a gifted printmaker and was capable of advanced experimentation, having polished his technique with printers in Paris. He was superbly accomplished from a technical perspective. Some of his later prints are quite powerful, but I wouldn't put the number high after 1960.

**How difficult was it to collect Masson's illustrated books?**

I looked for many years to find some of the early illustrated books such as *Soleils bas*, 1924 (cat. no. 1) and *Simulacre*, 1925 (cat. no. 2). They were very hard to find. In fact I had been collecting Masson for twenty-five years before I found any of his early illustrated books. Most of them came from Sotheby's in 1985. Illustrated books were auctioned at Klipstein and Kornfeld, but they came up rarely and were often very expensive. It took me a long time to find them. Some I have never found. They have never come up for sale. It was only seven years ago that I was able to buy the portfolio of etchings in sanguine for *Sacrifices*, 1936 (cat. no. 12 a-e). I have only seen the etchings in black for *Sacrifices* in a private collection in New York.

Masson's work is often charged with sexual imagery. Some of his obscene works, which were published privately, are quite rare as well as quite remarkable. I only bought *Le con d'Irène*, 1928 (cat. no. 5) seven years ago, and it was the only time that I have ever seen it for sale. It is a beautiful book with five etchings that are extraordinary achievements. Each is like an intense ball of charged energy so strong it could almost catch fire.

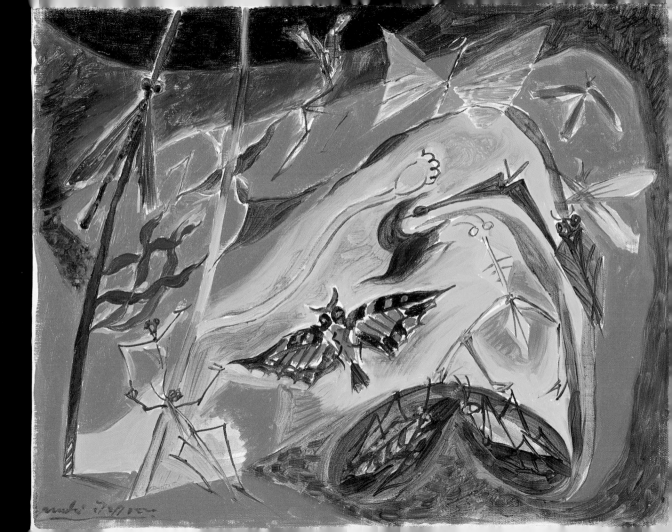

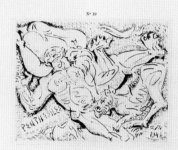

Inventeur au sens strict (son art étant essentiellement la formu-
lation de trouvailles faites dans la sphère de l'intelligible comme
dans celle du sensible), André Masson, plus encore qu'un artiste
qui sait voir et faire voir de façon neuve, est un artiste visionnaire.
L'infini qu'une minute d'ouverture totale lui découvre dans les ner-
vures d'une feuille, la membrure d'un insecte ou les replis d'un
corps féminin, il l'enclôt dans les limites de l'œuvre, sans pour autant
le limiter. Qu'il s'attache à restituer le choc reçu d'une présence
vivante ou que sa quête d'un monde rendu à la pureté sauvage
l'emporte jusqu'aux origines de l'homme, voire même jusqu'aux
en-deçà de la nature, l'on dirait qu'il récuse toute autre perspective
que celle des cosmogonies et que, pour lui, rien ne vaut qui n'appa-

N° 19

raisse comme éclosion ou comme révélation : naissance des êtres
et des choses qui constituent nos entours, surgissement des figures
et des idées dans l'antre de notre esprit.
   Usant des registres les plus différents selon l'humeur et selon les
exigences momentanées de la capture (depuis la notation en écri-
ture cursive jusqu'à la mise en absolus idéogrammes), agissant
en peintre, en dessinateur ou en graveur dont les multiples recours
ne sont pas de gratuites démonstrations de virtuosité mais des appro-
ches pour donner sa signification la plus profonde au beau mot
d'« imagier », André Masson bâtit pièce à pièce, par brusques ful-
gurations, une sorte de légende de ses instants traversée de bout en
bout par un souffle de Légende des siècles.

MICHEL LEIRIS

N° 10

FIG. 3

*Le monde imaginaire d'André
Masson: Eaux-fortes et
lithographies 1934—1963*
Galerie Gérald Cramer
28 October — 6
December 1963
Reproduced left:
*Penthésilée* (CAT. NO. 46)
and right:
*Rêve d'un futur désert*
(CAT. NO. 31)

## What is your response to the various periods of Masson's career?

There are five periods, all of them beautiful. From a remarkable start when Masson was
influenced by Cubism in a surrealist context, he moved into automatic drawings and sand
paintings. This first period is well demonstrated in his rare and magnificently illustrated
book *Ximenès Malinjoude,* 1927 (cat. no. 4). Masson's second period is marked by full-blown
Surrealism during his experiences in Spain in the thirties. I love that period, which is full of
masterpieces. It is the moment of Masson's insect pictures and violent subjects of battles and
matadors and blood. You see a wild, undisciplined imagination sometimes overwhelming
you and sometimes beautifully transformed into a quiet and moving picture. Then Masson
moves to America during the war. This is his third period, and some critics consider it his
greatest. He painted a number of outstanding works inspired by the romance of Native
American mythology and the New World. You get a sense of the mysteries of early religion
through his use of wonderful colours, the earth colours.

   In his fourth period, Masson returns to postwar France and begins to produce litho-
graphs that are extraordinary. They are impressionistic and very beautiful. I think *Voyage à*

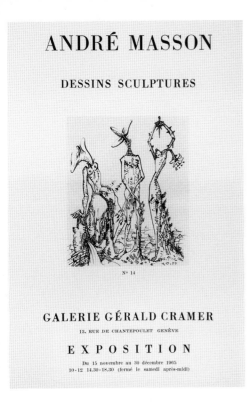

FIG. 4

*André Masson:*
*Dessins Sculptures*
Galerie Gérald
Cramer
15 November –
30 December 1965
*Trois métamorphoses*
(CAT. NO. 21)
reproduced on cover

*Venise* is one of the most exquisite illustrated books of the twentieth century. I do not see how this could be disputed. The spontaneity and loveliness of these pictures of Italy and San Marco is an absolute *tour de force*. It is such a rare book that I have only seen it once for sale, when I bought it.

In his later work Masson experiments with quasi-abstraction through Chinese calligraphy and a Zenlike state of mind. I can see it is attractive but find it difficult. In the sixties Masson seems to revert to aspects developed throughout his career. He is a challenging artist because of the way he redefines himself and his vision. The complexity of Masson's work in the postwar era affected to some extent the ability of some people to appreciate him. The repetitiveness and the difficulty of the vision of the last period did not help Masson achieve the recognition that he well deserves.

### How do you respond to the explicit sex and violence in Masson?

I have no trouble with the violence and blood, which are recurring themes in Masson's work. I think Masson transcends the violence. The pictures, bloody as they are, are on the whole beautiful. Beauty emerges from the violence, and there is an energy and fury that is contained on the canvas within the four edges of the frame. I have no trouble appreciating and liking these pictures. I have never felt that Masson is at his absolute best when the sexual impulse becomes the dominant theme. In some cases Masson made the imagery more obscene than it needed to be, but I should qualify that. When the subject matter is the female sexual organs, which is a constant theme, some of his drawings are absolutely marvellous. In the large ink drawings made in Spain during the thirties, woman and vegetation are associated in biomorphic abstractions where mythology revolves around the womb as an enormous door to the abstract universe. These drawings are very powerful. Many of Masson's drawings are completely successful in allowing the sexual dimension to act as an integral part of a harmonious picture or theme. He even succeeded with pictures that judged today would be obscene like *Le con d'Irène*. They are magnificent. Occasionally I find a jarring element, but on the whole Masson has created more magnificent pictures than most artists could do in a lifetime.

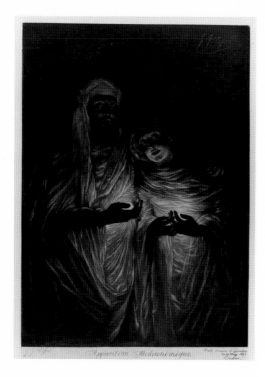

FIG. 5
James Tissot (French, 1836–1902)
*Mediumistic Apparition* (L'apparition médiumnique), 1885
Mezzotint on chine appliqué, 48.9 x 34.2 cm (imp.)
Gift of Allan and Sondra Gotlieb, 1994 94/273

Masson linked the process of his automatic drawings with the methods of those who speak with the dead: "Automatic drawings are like the drawings of mediums: things develop without break between the moment of their realization until the realized object." — André Masson, *Vagabond du surréalisme*. Paris, 1975, p. 80–81.

## Can you elaborate on how you connect Tissot and Masson?

One of the things that directed me to Tissot was a sense of something surrealistic in his work — there was some kind of theatre, some kind of unreality, indeed a strangeness in Tissot. This is particularly true of all of his late works, which produce an almost dreamlike sense (fig. 5). Even before I knew Masson's work, I was attracted to the "sur-real" of surrealism meaning "beyond reality." In Tissot's famous series *Femme à Paris,* the dandies who appear in the Paris salon are stiff and unreal. He's not trying to create movement, and you can see that he wanted the figures to be wooden. Tissot freezes the frame in a strange way that speaks to something beyond reality or a dimension of hyper-reality. This is why he is different from so many Victorian artists.

## What is the relationship between Masson and the American Abstract Expressionists?

In the late fifties, Masson's reputation was considerable for his influence on the Abstract Expressionists and action painters (such as Jackson Pollock). In the early sixties, when I began collecting Masson's work, the most influential American critic was Hilton Kramer, who wrote for the *New York Times.* He hated Masson, whom he considered a "literary" painter since the art always refers to a narrative of some sort. According to Kramer, narrative was the greatest curse. For a critic like Kramer, who viewed art as a progression, the highest achievement was abstraction. At that time "action painting," a term coined by another critic Harold Rosenberg, was

considered the most avant-garde in America. Masson was associated with the invention or creation of pure inspirational abstract art like automatic drawing, but he did not sustain it. The critic Clement Greenberg (1909–1994) credited him as a vital influence on the action painters. Greenberg claimed that after Picasso, Masson was the seminal painter of the twentieth century but tragically unfulfilled, since he never dropped the figurative.

**What is your assessment of Masson and his larger role in twentieth-century art?**

This was a man who was in the mainstream of French culture and thought. When he came to the United States he did not learn English. Yet he found great material in America and this makes him stand out from other émigrés.

Masson is quintessentially a man of French culture who seems to have moved with some of the dominant experimental thinking in France. His friendship with the writer and cultural historian/theorist Michel Leiris (1901–1990) and his interest in Chinese culture are somewhat characteristic of a postwar intellectual interest in France. Masson is a French figure. This has affected the way he has been seen in the United States, which pits New York versus Paris. Although Masson had a great period in America, he belongs culturally to a different tradition. If we go back to Kramer and Greenberg's perspective, Masson arrived at the gates of abstraction with automatic drawing. He was able to see the promised land as defined by the American critics, but being European and Old World, he turned his back on the New. This is difficult for Americans, who consider themselves the conquerors in the history of art. To see someone who dabbled in abstraction, who was able to see it and receive it, but who walked away from it, that is a much greater insult than not doing it at all. Rather better a Balthus than a Masson.

**Tell us about your connection with the American dealers who have championed Masson's graphic oeuvre.**

There were two dealers after the war, Larry Saphire and Timothy Baum who had exhibitions of Surrealist prints. My initial plan was to become a collector of Surrealist prints (Seligmann, de Chirico, Miró, and so on). I lost interest when I realized that there were not that many great Surrealist prints. Max Ernst did some impressive things. Masson was of more interest to me. I discovered that Saphire was a walking encyclopedia of knowledge about Masson, whom he knew. I learned that he was writing a catalogue raisonné of the prints and subscribed to the first volume many years before it was published. Saphire is a scholarly and painstaking worker, and now he's working on volume two.

I purchased a number of Masson's prints from Saphire, who ran the Blue Moon Gallery in New York. Over the years I became friendly with him and we spent a long time talking about Masson. I learned a great deal from him. He is the greatest font of knowledge on Masson and has a significant Masson collection of his own. Saphire acquired from Masson a number of printing plates that were made around 1933 but from which no prints had been pulled. In 1972 Saphire printed about eight to ten prints with Masson's permission in small editions of ten or fifteen. They are quite handsome but not period prints. My hope is that Saphire will complete volume two of the catalogue because he knows so much. There is also a useful catalogue raisonné of the illustrated books that he did with Patrick Cramer. Another American dealer of Masson's prints was David Tunick in New York. I purchased a number of prints from Tunick.

**Did you ever meet Masson?**

No, I never met the artist. I have nothing but regret.

**How do you see Masson's legacy now that your collection is in the Art Gallery of Ontario?**

The Art Gallery of Ontario has a wide, catholic collection and one of the most significant holdings of prints and drawings in North America. For a great museum in a leading industrialized nation, the breadth of its holdings is a key requirement. I hope that this Masson collection will lead to a renewed and vigorous interest in Surrealism and in the evolution of printmaking in the twentieth century. When the history of art is written for this century, in order to understand the forces that have contributed so importantly to what it was, I think Masson must be counted as one of the pioneers and one of the most creative minds. Since Masson brings an extra dimension into so many of the main currents of Modern art, the Masson holdings at the Art Gallery of Ontario will attract scholars and people who want to see and be exposed to some of the most beautiful things that artistic inspiration has created.

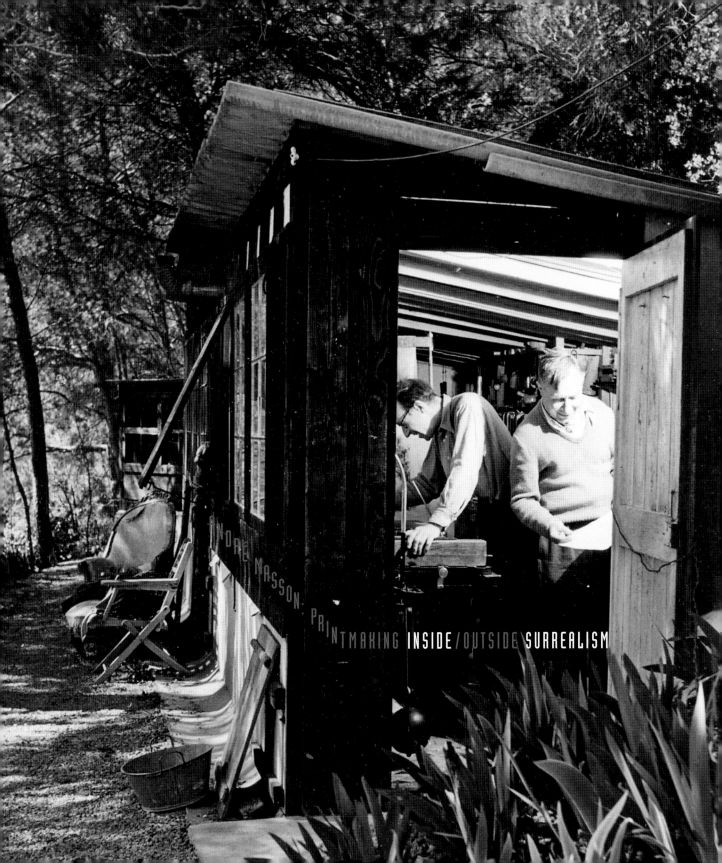

ANDRE MASSON: PRINTMAKING INSIDE/OUTSIDE SURREALISM

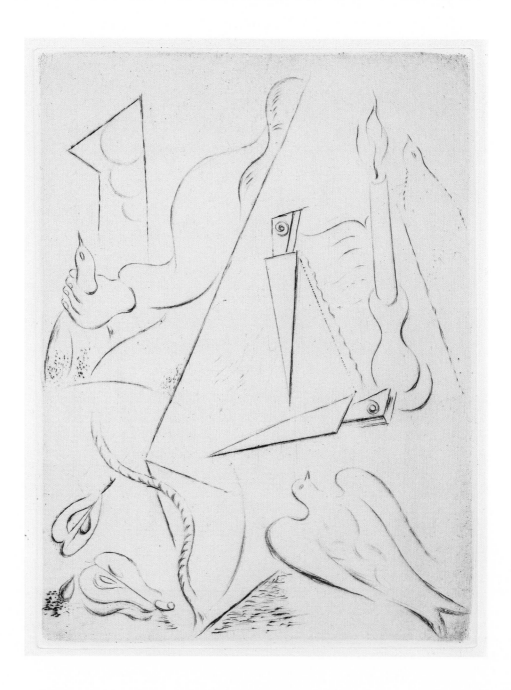

CAT. NO. I / FIG. 6

*Untitled*, 1924,

in Georges Limbour, *Soleils bas*

*"No taboo can intervene to drive me to the fixity of one style."* —ANDRÉ MASSON[1]

A NDRÉ MASSON WAS AN "INSIDER" of Surrealism by 1924 when he was invited to join the fledgling group of Surrealists by its self-appointed leader André Breton. While Masson was one of the few artists with even modest printmaking experience to enter the Surrealist camp, many consider the book illustrations he made during his early years in the group to be quintessential Surrealist statements and the high point of the artist's graphic oeuvre. These early book illustrations were, however, just the beginning of Masson's lengthy printmaking career inside and outside of Surrealist circles.

For Masson, printmaking was linked inextricably to his inventions in other media, and thus his prints must be considered as central to our understanding of a long and productive career that encompassed painting, drawing, sculpture, etching, drypoint, aquatint, engraving and lithography. Among the artists whom we think of today as Surrealists, Masson had a particularly strong affinity for printmaking. He was willing to invest the time and expend the energy required to become a printmaker of consequence by working with many of the best printers of his day. An examination of Masson's printed work reveals that for him prints were more than a way to make multiples of images found in his drawings and paintings. From the beginning of Masson's career to its culmination six decades later, printmaking allowed him to investigate creative processes that extended his explorations in painting and drawing. In addition Masson, who had a lifelong passion for literature, employed prints as book illustrations, which he created in a dialogue with texts written by his friends both inside and outside Surrealism.

During the 1920s, Masson experimented with automatic drawing and biomorphic abstraction in collaboration with a number of Surrealist poets. Thus he contributed the visual means to further Surrealism's goal to subvert reason and investigate the workings of the unconscious. Furthermore, his fascination with metamorphosis in all its forms and his preoccupation with eroticism not only informed much Surrealist thought, but provided the fuel for a lifetime of creativity that was to propel him well beyond Surrealism.

Departing from the Surrealist camp in 1929, Masson was reconciled with Breton in 1936, but fell out of favour again in 1943. Interviewed late in life, Masson reflected: "I didn't want a prison, didn't want to lock myself into a formula. And in the Surrealist circles of Paris, they found it odd that sometimes I took 'vacations' from Surrealism, and sometimes did things that had nothing to do with Surrealism; but it was because Surrealism would bore me, and then I would have to do something else."[2] While Surrealist practice is linked with much of Masson's oeuvre, he could not be contained by a group aesthetic or shared belief. Instead he followed an independent path in his approach to art and life. As one of the best-read and intellectually curious artists of his generation, Masson embraced many philosophies that ultimately informed the style and iconography of his prints. As an "outsider" of Surrealism, Masson made prints that reflect a multiplicity of sources absorbed in his maturity, from Impressionism, late Monet, and J.M.W. Turner to Chinese paintings and drawings and Zen Buddhism. Over a career spanning sixty years, Masson's graphic oeuvre remains complex, poetic, stylistically varied, psychologically layered and philosophically dense. His work is challenging and difficult to classify. He remains one of the most unappreciated artists of the twentieth century.

## Early Surrealism and Automatism

In the winter of 1921 Masson rented a Paris studio located in the 15ᵉ arrondissement at 45, rue Blomet. His neighbour was Joan Miró who worked in an adjacent atelier in the same building. The following year, the rue Blomet was a centre of artistic ferment, the gathering place of a group of youthful artists, writers and poets who shared ideas generated through reading German Romantic literature, the philosophy of Friedrich Nietzsche, the erotic writings of the Marquis de Sade and the proto-Surrealist texts of Isidore Ducasse, the "comte de Lautréamont." The circle included the writers Georges Limbour, Michel Leiris, Armand Salacrou, and later Robert Desnos and Marcel Jouhandeau. At first this group was independent from nascent Surrealism as practiced by André Breton's literary and artistic circle, which gathered in the rue Fontaine, but it was inevitable that the rue Blomet group and Masson, in particular, should come into Breton's orbit. The dealer Daniel-Henry Kahnweiler was the catalyst.

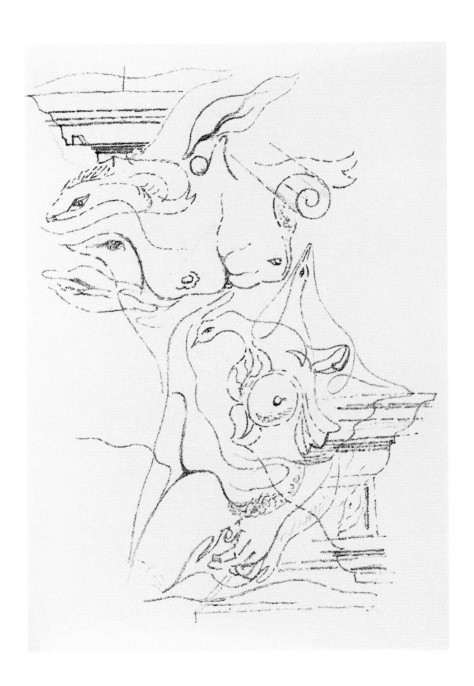

CAT. NO. 2 / FIG. 7
*Untitled*, 1925,
in Michel Leiris and André Masson
*Simulacre*

Masson's first one-man exhibition was held at Kahnweiler's Galerie Simon in early 1924. Breton visited the show and purchased a painting that demonstrated formal aspects of Analytic Cubism filtered through a symbolic and Surrealist sensibility. He sought out Masson in his studio. Shortly thereafter Breton wrote the first Surrealist manifesto and founded the magazine *La Révolution Surréaliste*. He was impressed by Masson's automatic drawings and reproduced one in the first issue. This was a technique Masson had developed to allow his pen to wander undirected and without recourse to composition or subject matter. Executed in an almost trancelike state, which Masson likened to that of a spiritualist medium, automatic drawings suggested vestiges of images that the artist sometimes later enhanced, allowing them to emerge from the abstract web of tangled lines. These additions were made in the same rapid spirit as the initial drawing and were left purposely ambiguous to promote an open-ended reading. Masson claimed that he began these drawings with no preconceptions, and that the process was like writing a letter to himself whereby "he needed no aesthetic preparation, purpose, or research — the content of the drawing was a picture of his interior being."[3] Breton felt this technique could probe the unconscious (and thus improve consciousness) by providing a visual equivalent for "pure psychic automatism" that would work outside of "control exercised by reason," as he defined Surrealism in his manifesto.[4]

By the end of 1924, Masson had taught himself to make prints by reading a book on etching. He then executed his first original prints (four etchings with drypoint) to illustrate *Soleils bas* (cat. no. 1/fig. 6), a book of poems by Georges Limbour (1900–1970) that was published in a limited edition by Galerie Simon. Although there is some evidence of automatism found in these prints, elements such as dead birds, knives, pears and a candle derive from a Cubist syntax first developed in painting. In an interview Masson explained, "Miró and I said Cubism must be broken. Miró said, 'I'll break their guitar.' And I said, 'I will make their birds bleed,' because whenever I painted birds, they were dead: this was a declaration of war."[5] Masson's enigmatic subject matter does not relate directly to Limbour's poetry, but rather stands in a parallel relationship to it, drawn from the subconscious depths.

For the next four years, Masson continued to supply original prints as counterpoints to the poetic writings of his literary friends. *Simulacre* (cat. no. 2/fig. 7) was the first published collection of poetry by the writer and ethnographer Michel Leiris (1901–1990), and the first attempt at lithography by Masson. The seven lithographs repeat some elements from the previous drypoints, but with more emphasis on the relationship of the human figure to classical architectural details. The relationship of author to artist and vice versa has provided a myth

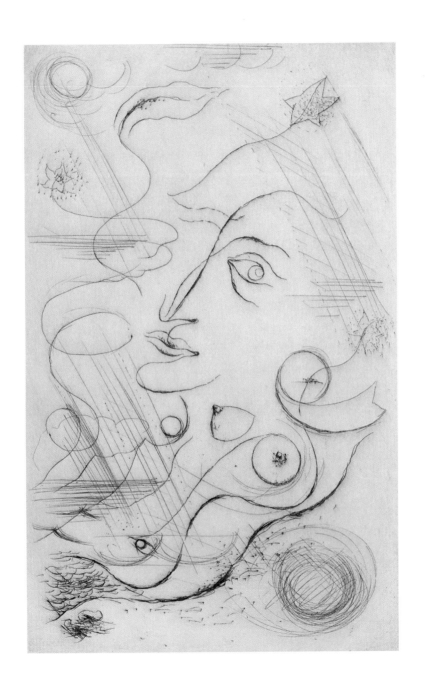

CAT. NO. 3 / FIG. 8

*Untitled,* 1926

in Robert Desnos, *C'est les bottes de 7 lieues.*

*Cette phrase "Je me vois"*

concerning the making of this book, which gives some insight into the desired nature of the collaboration. Late in life, Leiris remembered the project with Masson: "*Simulacre* was written at 45, rue Blomet and Masson and I signed it together. We had made *Simulacre* alongside one another in order to make it clear that, as illustrator, he was not in an inferior position to the author as is usually the case."[6] The existence of two preparatory drawings demonstrates that the book was not the product of joint automatism. Nonetheless the author and artist were no doubt on the same subconscious wavelength, and the lithographs engage the poems in a dialogue rather than directly illustrating them.

Masson's third illustrated book, and one of the most successful of his career, followed in 1926. Here he attempted to follow more closely the subject matter of the text in collaboration with the Surrealist poet Robert Desnos (1900–1945). The four drypoints for *C'est les bottes de 7 lieues* highlight in print Masson's distinctive automatic drawing style and show to advantage the use of colour for the first time with bistre ink. Motives such as the pierced heart and leaf flowers executed with looping whiplash lines suggest a closer affinity to Miró's iconography and execution than ever before (cat. no. 3/fig. 8).

In 1926 Masson made the first of his now-famous sand paintings at Sanary-sur-Mer. They were made by drawing automatically with glue on canvas, and then sprinkling coloured sands on top to achieve the spontaneity of drawings. A similar play between figuration and automatic abstraction is the basis of Masson's six small etchings that illustrate Marcel Jouhandeau's novel *Ximenès Malinjoude* (cat. no. 4/fig. 9). Like his friend Yves Tanguy (fig. 10), who also made automatic drawings, Masson would have argued that a literal reading of automatic forms went against the spirit of Surrealism. In the words of one author, such a reading missed "the fact that the image is itself but a metaphor, a covering, for the hidden 'beyond' of the springs of association and interpretation in the minds of artist and viewer."[7] *Ximenès Malinjoude* was the fourth book with the imprint of Kahnweiler's Galerie Simon, but the pace of annual publication was about to be temporarily halted due to lack of sales and a shift in Masson's aesthetic away from automatism and toward prints of an explicit nature that Kahnweiler considered "too realistic."

While a ban existed on the display of erotic works in public exhibition during the twenties, illustrated books were published surreptitiously despite the threat of prosecution. Masson agreed to contribute five etchings for Louis Aragon's pornographic prose *Le con d'Irène* (cat. no. 5/fig. 31) – a book that sold out in three months before the end of 1928. Published anonymously by Pascal Pia (who was to author the first monograph on Masson in 1930), the etchings are evocative of the writings of the Marquis de Sade (1740–1814), a hero of the early Surrealists for his erotic writings.

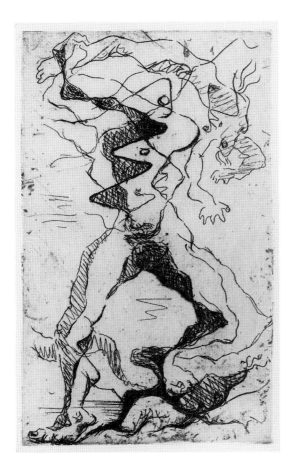

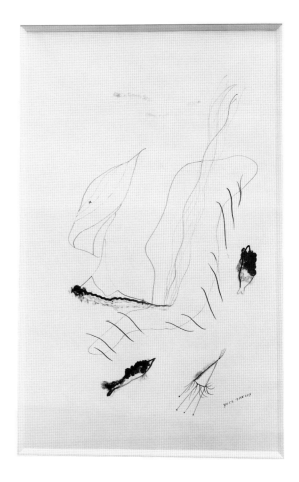

CAT. NO. 4 / FIG. 9
*Untitled*, 1927, in Marcel Jouhandeau, *Ximenès Malinjoude*

FIG. 10
Yves Tanguy (French, 1900–1955), *Drawing (Untitled)*, c.1927
Pen and ink on wove paper, 48.4 x 30.5 cm
Art Gallery of Ontario, gift from the Junior Women's
Committee Fund, 1963 62/39

By the end of the twenties, dissension in Surrealist circles saw Masson and Breton part ways. For Masson Surrealism was no longer a movement of collaborators since Breton had completely assumed the direction of the group in terms of its politics and organization. The year 1929 witnessed Masson's departure and Breton's second Surrealist manifesto. Automatism was no longer a central activity according to the dictates of Breton. He proposed a new agenda for Surrealism marked by the arrival of Salvador Dali, whose illusionistic dream and hallucinogenic imagery Masson detested.

## Sacrifices and Spain in the 1930s

Masson was joined in his exodus from Surrealism by Michel Leiris, Georges Limbour and Robert Desnos. Together the rebel Surrealists formed a loose association through their contributions to the journal *Documents*, founded by their friend Georges Bataille (1897–1962). Bataille had never been a Surrealist. Indeed he described himself as Surrealism's "old enemy from within," and held Breton in contempt. He was opposed to the idealist concept of man found in Surrealism, which he repudiated for a dark and brooding pessimism. Bataille's world view and penchant for "intellectual violence" found a kindred spirit in Masson. From 1931 to 1933 Masson produced a disturbing series of prints and drawings of violent and erotic subjects known as *Massacres* (cf. cat. nos. 7–11). Not surprisingly, Masson and Bataille collaborated on a project initiated in 1933 and realized in 1936 called *Sacrifices*.[8]

Bataille's essay for *Sacrifices* is a philosophical meditation on death, while Masson contributed five etchings related to the darker myths of Middle Eastern and Greek origin that focus on themes of sacrifice, eros and thanatos (cat. no. 12 a–e). Masson's prints join violence and eroticism in his conception of "the gods who die" in Western culture: Mithra (Persian), Orpheus (Greek), the Crucified One (Judeo-Christian), the Minotaur (Cretan) and Osiris (Egyptian). These strange and esoteric, yet beautiful prints distinguish a high point in Masson's development as a printmaker. The theme of violence and eroticism would soon be taken up again against the backdrop of the Spanish Civil War.

The riots of 6 February 1934, led by extreme right-wing groups in Paris, prompted Masson and his future wife Rose Maklès to depart for Spain. After travelling around the country, they eventually settled in Tossa de Mar and became thoroughly involved with Spanish life and culture. Marko Daniel, in a recent essay, claims Masson "approached Spain with the preconceptions of a well-read, cultured tourist."[9] Nevertheless the social and political events of the Second Spanish Republic leading to the Spanish Civil War of 1936–39 were about to inform his art. In 1934 Masson painted *Le champ rouge* (cat. no. 18/fig. 2), which shows a red field populated by various insects, including two praying mantises in the foreground. This was a favourite motif of the Surrealists since the female devours the male after mating. As a creature of uninhibited violence, the praying mantis became an appropriate symbol for the Surrealists to link eroticism and death.[10] *Le champ rouge* is an extension of Masson's preoccupation with violence in the "massacres" of the early thirties, and at the same time speaks to the civil fighting initiated by Franco's Fascist aggression against the Republican government. Daniel concludes that Masson's work in Spain "is not so much a political symbol, nor even about the social reality of the country, but owes more to...[his] vision of eternal Spain as a

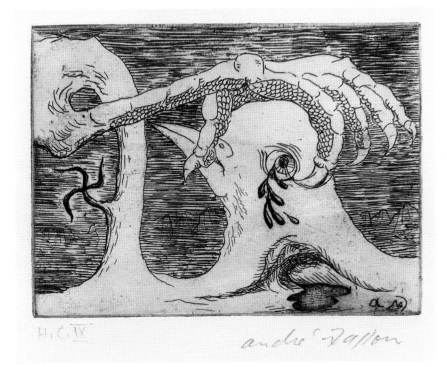

CAT. NO. 20 / FIG. 11
*L'Espagne assassinée,* 1938
from the album *Solidarité*

place of death, sacrifice and ritual, a destination for holidays in mythology."[11] While the portfolio *Sacrifices* was published late in 1936 after Masson and his family had left Spain following the outbreak of the Spanish Civil War, he had travelled well beyond mythological tourism with virulent anti-Franco drawings that measure the level of his political engagement (for example, *Le thé chez Franco*, published on the cover of the February 1939 issue of *Clé*).

In 1938 Masson was invited to contribute an etching to an album entitled *Solidarité* to raise money for Spanish orphans of the Civil War.[12] His print *L'Espagne assassinée* (cat. no. 20/fig. 11) captures vividly the notion of civil war in the image of the bird that attacks itself and enucleates its eye. The bird is blinded just as Spain attacks itself blindly in civil combat. Masson equates Franco with German fascism by incorporating a swastika (albeit reversed in the printing process) as an appendage to the attacking claw of the bird. This marks the first print collaboration between Masson and the noted British printmaker Stanley William Hayter (1901–1988). Like Masson Hayter was deeply moved by the Spanish Civil War and was responsible for organizing the portfolio to raise money for Spanish orphans. Hayter was to become an important figure in Masson's printing career. With the threat of war in France, the relocation in 1940 of Hayter's famous printshop Atelier 17 from Paris to New York anticipated Masson's arrival in America.

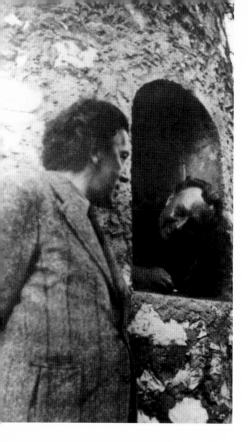

André Breton and André Masson,
c. 1940–41, Montredon.

## American Sojourn 1941–45

With help from Varian Fry of the America Rescue
Committee, the Masson family sailed to New York via
Martinique in 1941, along with the Surrealist Cuban
artist Wifredo Lam and André Breton, with whom
Masson had reconciled in 1936. Although the Massons
settled eventually in New Preston, Connecticut, the
artist took advantage of his proximity to New York to visit
Hayter's newly established Atelier 17. "Hayter's was the
only [graphic workshop] where I worked alongside other
artists."[13] There Masson made eighteen prints from 1941
to 1945 and learned much about printmaking from
Hayter and the artists who frequented the studio.[14]

*Rapt* (cat. no. 44/fig. 12) is perhaps the most automatic
print of Masson's career and precisely the kind of work
that would have endeared him to Hayter, who had
deployed automatism to release subconscious images in
his own prints since the thirties. *Rapt*, whose subject is
the abduction of a woman, recalls the classic automatic
drawings of 1924–27, but as Lawrence Saphire notes, the
print also relates to the *Massacres* of the early thirties when
Masson's work "dealt with sexual brutality towards
women."[15] *Rapt* also brings to mind Miró's *Black and Red
Series* of 1938 with its ideograms incorporated in a
dynamic automatist matrix (fig. 13).[16] It was the charac-
ter of Masson's automatic technique with its allover linear
calligraphy that prompted critic Clement Greenberg to
acknowledge the pivotal role Masson played in anticipa-
tion of Abstract Expressionism in New York.[17]

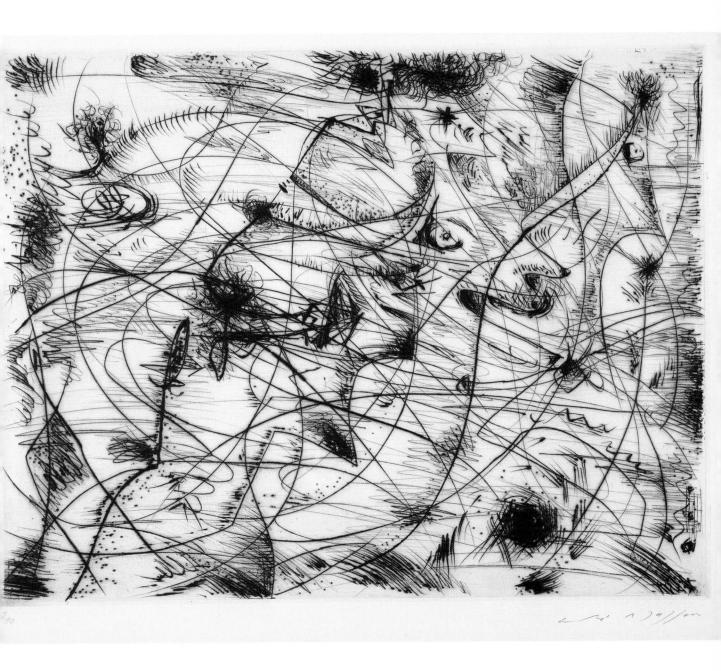

CAT. NO. 44 / FIG. 12

*Rapt,* 1941? 1946?

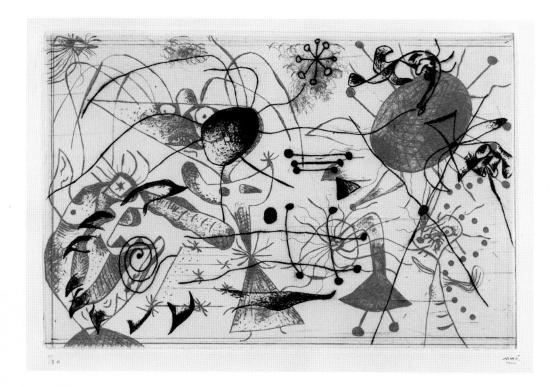

FIG. 13
Joan Miró
(Spanish, 1893–1983)
*Untitled* (pl. 5) from
*Black and Red Series*, 1938
Etching and drypoint
on wove paper,
16.7 x 25.7 cm
Art Gallery of Ontario,
gift of Allan and
Sondra Gotlieb, 1995
95/468

Masson experimented at Hayter's with both black ink and sanguine versions of the drypoint and engraving *Le génie de l'espèce* (cat. nos. 25–27). Here the biomorphic abstraction of the "genius of the species" reveals the influence of various artists associated with Hayter in the forties including Miró, Tanguy, Matta and Lam (the latter three were also in exile and printed at Atelier 17 in New York) (cat. no. 26/fig. 14). Masson's work during his American period was noted particularly for his observation of the microcosm of nature with its elemental forces of growth and germination. The creatures of *Le génie de l'espèce* seem to be both animal and vegetable, and not unlike those that populate *Les fruits de l'abîme* (cat. no. 28/fig. 15), a print published in a 1942 album to support the fledgling New York Surrealist review *VVV*.[18] The tropical vegetation and totemic references in this soft-ground etching may refer to Masson's Martinique experience enroute to America and also display stylistic affinities with the work of Wifredo Lam. To achieve the textured look of the background, Masson used a technique learned from Hayter of pressing a cloth into the soft ground.

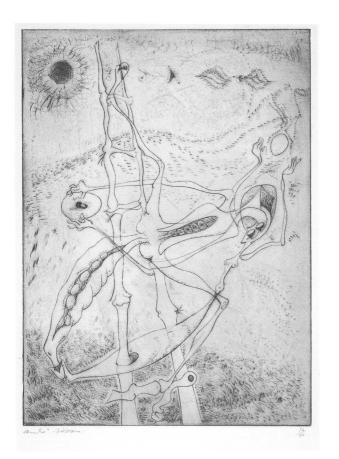 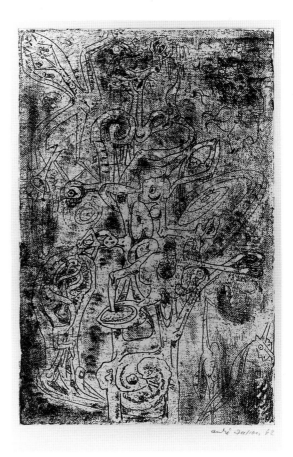

CAT. NO. 26 / FIG. 14

*Le génie de l'espèce*

1942

CAT. NO. 28 / FIG. 15

*Les fruits de l'abîme*

1942

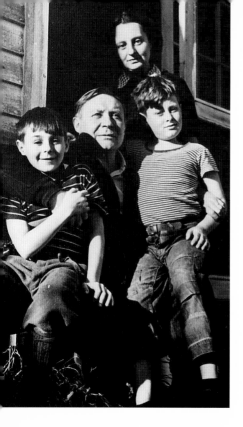

The Massons: Diego, André,
Rose, Luis, c. 1942, New
Preston, Connecticut.

Masson's most ambitious print in terms of scale and subject is the etching and drypoint *Rêve d'un futur désert* (cat. no. 31/fig. 16), dated securely to the fall of 1942. In this apocalyptic image an asteroid dive-bombs a "skull city" at the top of the composition, while below the mists part to reveal a fantastic landscape of pyramids and Piranesi-like prisons.[19] Roger Passeron interpreted the iconography of the print as witness to the artist's anxiety that the land would be reduced to a desert in the aftermath of war. According to Passeron, this anxiety was experienced by Masson in combat during World War I and later as a civilian in Barcelona at the beginning of the Spanish Civil War.[20]

*Rêve d'un futur désert* finds its genesis in a 1938 ink drawing that was published in the compendium of Masson's drawings: *Anatomy of My Universe*, 1943. At his home in New Preston, Masson copied the drawing to an etching ground, using a mirror to get as close as possible to a line-for-line transferral.[21] He remembered etching the copper plate with nitric acid at his home in the country and then working the plate with drypoint to strengthen certain lines while it was still submerged in acid. Evidently Chagall came to visit in the midst of this operation and was flabbergasted to witness Masson's method of working with his fingers dipped in acid.[22] Hayter was responsible for printing approximately half of the edition of *Rêve d'un futur désert*.[23] The plate was so large (19 x 25 inches) that no press at Atelier 17 could handle the printing, so Hayter was forced to find one elsewhere.

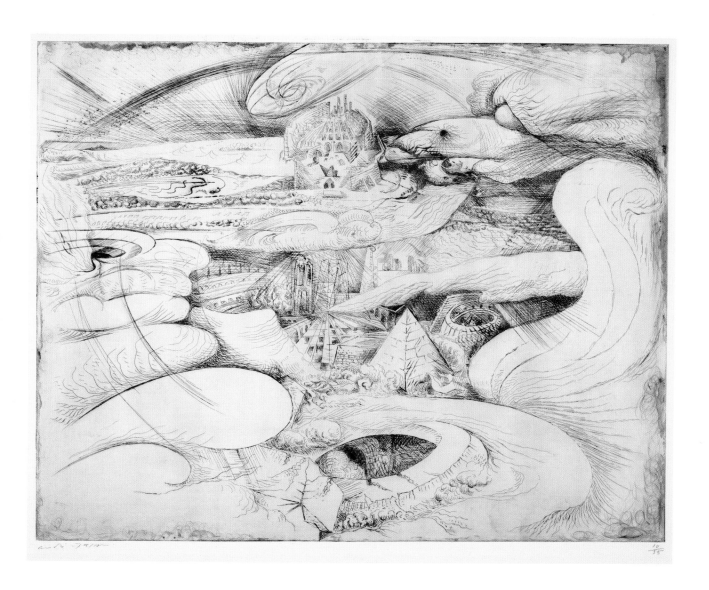

CAT. NO. 31 / FIG. 16
*Rêve d'un futur désert*
1942

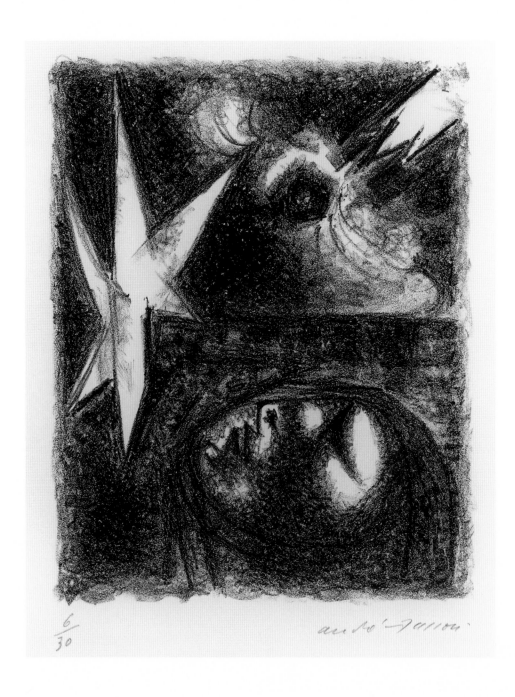

6/30

andré masson

CAT. NO. 35 / FIG. 17

*Résurrection*

1945

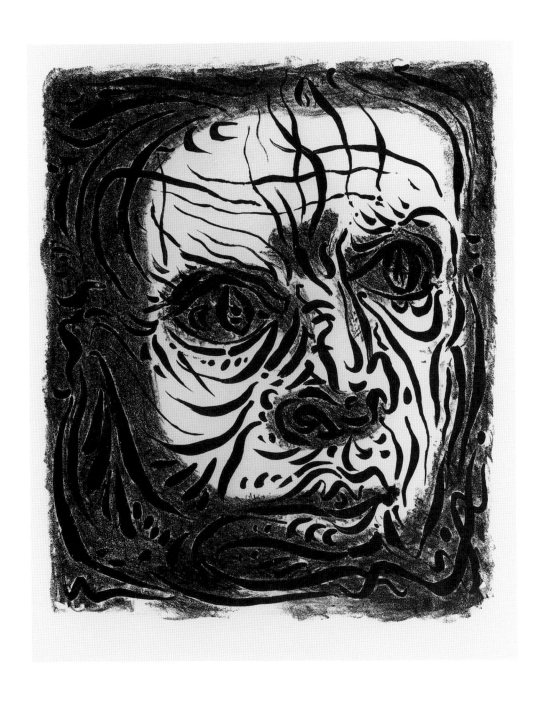

CAT. NO. 37 / FIG. 18

*Le plus cruel de tous les animaux*, 1945

in André Masson, *Bestiaire*

Masson did not make many lithographs before arriving in the United States. At the end of 1944, however, he focused on this technique through the impetus of George Miller's printing studio in New York. *Résurrection* (cat. no. 35/fig. 17) is a good example of the way Masson preferred to use his lithographic crayon for atmospheric effect rather than for pure drawing. Masson expressed great enthusiasm for the medium of lithography and began an important project, entitled *Bestiaire,* with Miller shortly before leaving New York for France in 1945. *Bestiaire* is considered Masson's major graphic album in America and his first comprehensive illustrated album with original prints since the 1933 portfolio *Sacrifices.*[24] Masson, who like Bataille was pessimistic about mankind, tellingly used his own features as the model for the lithographic portrait from *Bestiaire: Le plus cruel animal de tous les animaux* (cat. no. 37/fig. 18).

## Postwar Europe

When World War II ended in 1945, Masson made immediate plans to return to his native land. That summer he wrote enthusiastically to Kahnweiler about his preoccupation with lithography: "Can you tell me if I will find, as soon as I arrive in France, a lithographer...I've done a lot of them recently and, by God, I can't let go of this means of expression. I'm making almost no etchings."[25] In his first years in America, Masson had focused exclusively on intaglio printmaking at Hayter's. His experience with lithography at George Miller's studio in late 1944 changed the direction of his work. According to Lawrence Saphire, "The newly discovered lithographic means of expression probably complemented the artistic freedom that Masson had been seeking since mid 1943, when he perceived his 'crisis of the imaginary,' the crisis which led him to move from formalized surrealist invention to a more personal and nature-oriented art no doubt motivated in part by his break with André Breton as well as by his restless nature."[26]

Upon his arrival in France, Masson began making lithographs at Desjobert's Paris atelier to illustrate Samuel Taylor Coleridge's poem *The Rime of the Ancient Mariner* (Le dit du vieux marin) (cat. no. 39). Masson's technical triumphs at Desjobert's include the introduction into his oeuvre of colour lithography. *Portrait d'Emily Brontë* (cat. no. 40) was made with black and red inks, while *Hespéride* (cat. no. 42/fig. 19) is the first lithograph to deploy more than two colours.

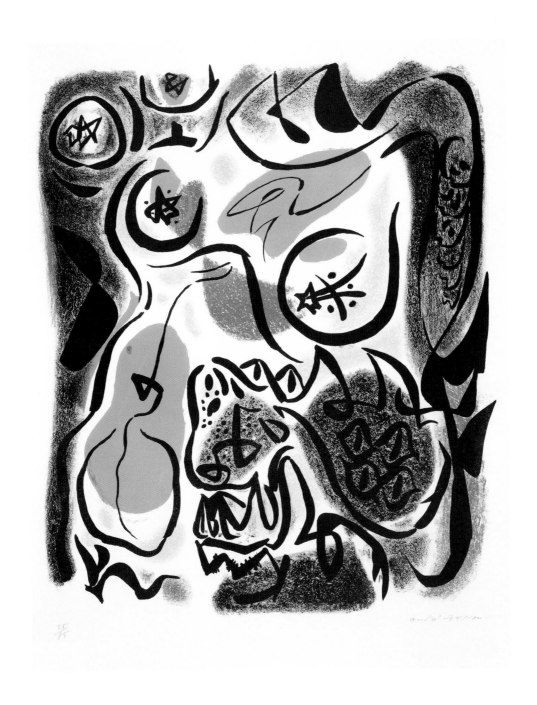

CAT. NO. 42 / FIG. 19

*Hespéride*

1947

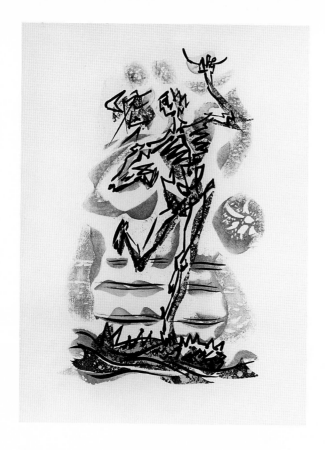

CAT. NO. 67 a/ FIG. 21
*Statue de Colleoni: la nuit,* 1952
in André Masson, *Voyage à Venise*

CAT. NO. 59 / FIG. 20
*Untitled,* 1949
in André Malraux, *Les conquérants*

During this time Masson had not abandoned intaglio printmaking. In late 1947 and throughout 1948 he explored the possibility of colour intaglio printing with one of the best printing workshops in Paris: Lacourière-Frélaut. Roger Lacourière (1892–1966), who came from a family of intaglio printers and engravers, established his reputation by the thirties as one of the finest printers (specializing in sugar-lift aquatints) to work with Picasso, Matisse, Miró and Dali. Masson was commissioned in 1947 by the Swiss publisher Skira to contribute prints to illustrate André Malraux's novel *Les conquérants* (cat. no. 59/fig. 20) about the 1927 Chinese Civil War. The book gave Masson a chance to build on the experience he had gained at Hayter's. Considered one of his most important deluxe illustrated books, it includes thirty-three aquatints made with the assistance of master printer Jacques Frélaut and demonstrates dramatic new advances in colour printing. Lawrence Saphire defined the technical innovations of these prints as the introduction of "variable depth biting to give one colour the appearance of several different ones, using the aquatint grain pushed with a rag to give almost imperceptible shading and definition to spaces between figures, and creating background effects similar to soft ground."[27]

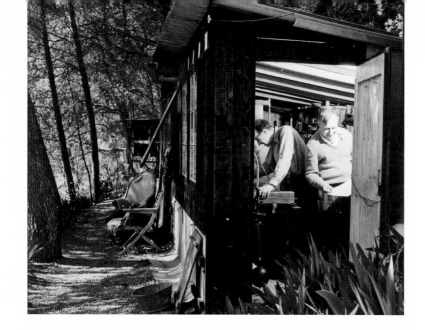

André Masson and
Léo Marchutz pulling
prints for *Voyage à Venise*
at Marchutz's studio,
Château Noir,
Aix-en-Provence, 1951
Photo: Robert Doisneau

In late 1947 Masson moved to Le Tholonet near Aix-en-Provence, where he lived in the shadow of the Montagne Sainte-Victoire, made famous by Cézanne. The following year he met the German artist/printer Léo Marchutz (1903–1976), who had installed a lithographic studio at the Château Noir near Aix. Their first effort together was the publication of Masson's *Carnet de Croquis* (cat. no. 63), which resulted after Marchutz showed Masson the benefits of transfer lithography. The technique provided Masson with the freedom to work outdoors directly from nature. As a result, Masson's immediate response to the landscape around Aix was made on transfer paper and then applied to lithographic stones in Marchutz's studio. The artist explained in 1949: "To seize, armed with a simple notebook, a lithographic crayon at hand, that which readily offers itself at first glance; then these sheets transferred to stone...[is] a way to more direct lithography and with a perfect fidelity: that alone allows the reconstitution, with all its nuances, of the study drawn on the spot."[28]

In 1951 Masson visited Italy, his first trip since 1914. This initiated his next *grand livre illustré* of colour lithographs. *Voyage à Venise* (cat. no. 67 a-c/fig. 21), one of his most accomplished books, was published in 1952. Having discovered from Marchutz how lithographs could be made spontaneously thanks to transfer paper, Masson readily deployed the technique once again. He had also learned from Marchutz how to make colour lithographs from a single pull instead of using a different stone for every colour as in the traditional printing of colour lithographs. Masson's evocative prints of Venice and the Italian landscape exhibit luminous atmospheric and transparent effects that with their pastel-like quality bring to mind his interest in J.M.W. Turner and particularly the Impressionism of Monet.[29]

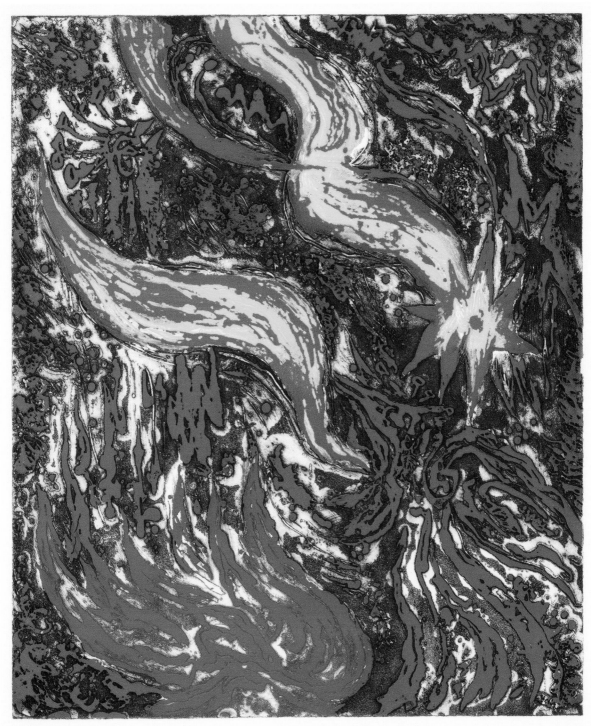

Between 1952–55 Masson returned to intaglio printmaking at the Lacourière-Frélaut workshop. There he worked directly with Jacques Frélaut on an extraordinary group of etching and aquatints that deployed multicolour ink printing. With colour central to the creative enterprise, deeply bitten plates were made with multiple colours that could be printed in a single pull, a feature Masson had already discovered while making lithographs with Marchutz. Masson found that the viscosity of ink sometimes resulted in overprinting and thus could create random effects (in keeping with a certain spirit of Surrealism) in intaglio prints such as *Les oiseaux sacrifiés* (cat. no. 72/fig. 22), *Chrysalides* (cat. no. 75) and *Oiseau cosmique* (cat. no. 76/fig. 23). These experiments, which built on Hayter's printing techniques, were brought to greatest fruition in the colour etchings for the illustrated book by Jean Paulhan, *Les Hain-Teny* (cat. no. 77). Saphire has identified the technical innovation of these etchings as the use of multiple relief plates inked simultaneously for all colours, an elaboration of Hayter's relief experiments, which gave not only a visual richness, but one that created a tactile experience from smooth to rough textures.[30]

Masson's interest in painters from the Far East may be dated as early as 1932 when he read a book on Zen archery. During his American period, he felt a particular kinship with Chinese art after a visit to the Museum of Fine Arts, Boston, where he saw the magnificent East Asian collections. In 1955 Masson attended the Peking Opera at the Théatre du Chatelet, and each time he took his sketchbook to record mime, gesture and movement. Calligraphic forms derived from Chinese or Japanese ideograms appeared in Masson's paintings and prints from this period prompting Roland Barthes to refer to them as "semiography."[31] A revival of interest in Zen on Masson's part led him to enjoy particularly the play between spontaneity and control derived from calligraphy in such prints as *Message de mai* (cat. no. 78/fig. 24) and *Acteurs chinois* (cat. no. 80/fig. 25). After a life of turbulence where the automatic gesture reigned supreme, it was perhaps a natural progression for the artist to resort to the quietude of Zen as his career matured. Yet it would be wrong to suggest that Masson's printmaking career ended on a quiet Zenlike note. He continued to make prints that revisited aspects of his earlier work almost to the time of his death in 1987. Perhaps it is fitting that his last great illustrated book project was *Une saison en enfer* (cat. no. 86/fig. 26) by the Symbolist poet Arthur Rimbaud (1854–1891), one of the Surrealists' favourite writers. Here Masson used vibrant colours to match the violence and intensity of Rimbaud's text.

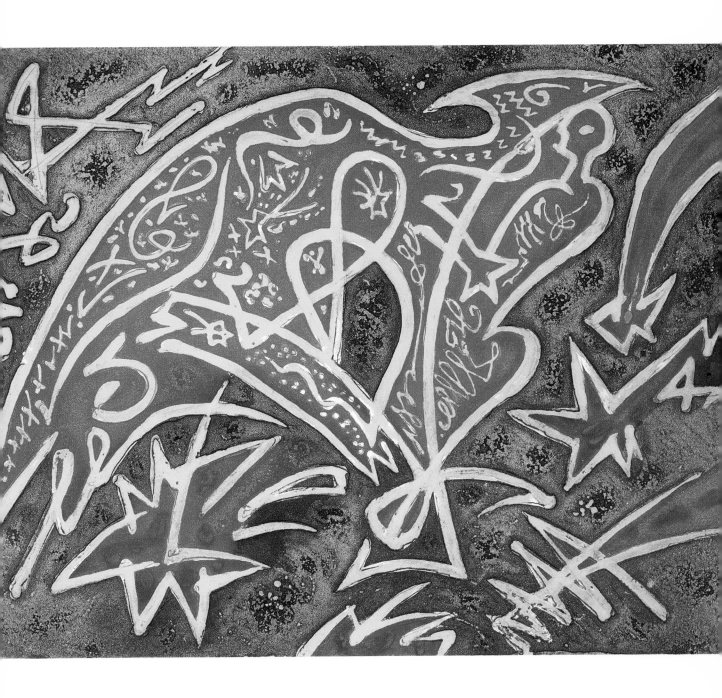

CAT. NO. 76 / FIG. 23

*Oiseau cosmique*

1955

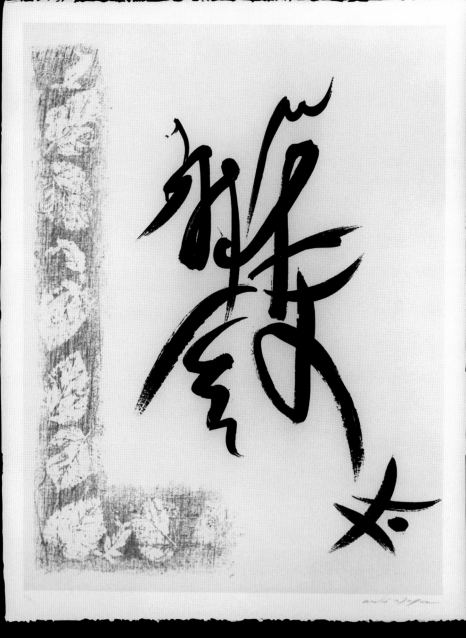

CAT. NO. 78 / FIG. 24

*Message de mai*

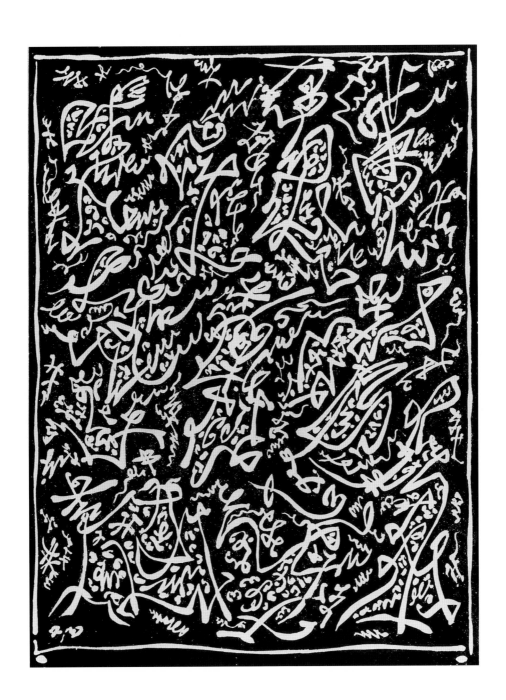

CAT. NO. 80 / FIG. 25

*Acteurs chinois*

1957

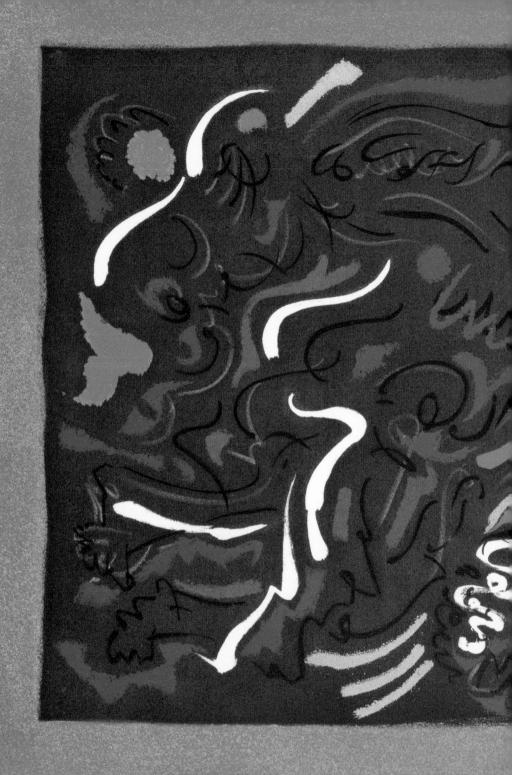

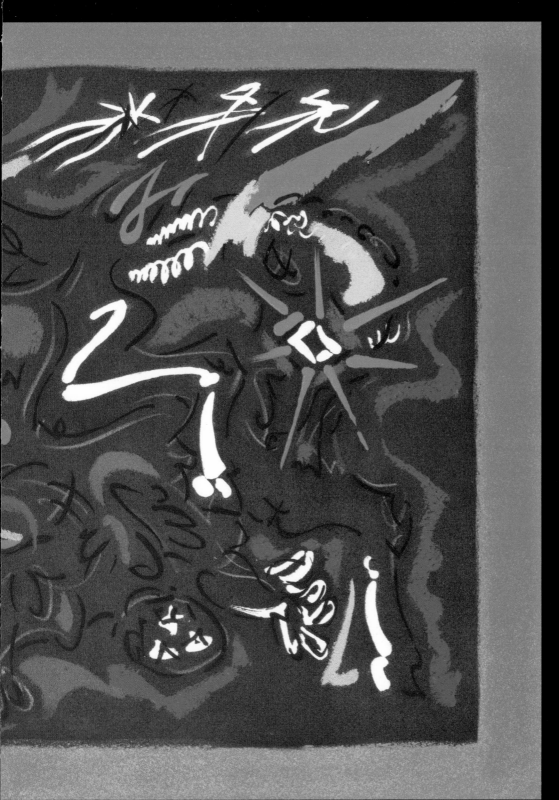

CAT. NO. 86 / FIG

*Untitled*, 1961

in Arthur Rimbaud

*Une saison en enfer*

André Masson examines
prints in his library,
26, rue de Sévigné, Paris,
c. 1970

Late in life Masson reflected on his activity as a printmaker and particularly on the absence of other artists in the printers' studios: "In the workshops, I was all alone, I was all alone at Mourlot's, at Lacourière's, and I wondered why, but I was with artisans who made the prints, and colour etching is a job for an artisan. One day, I was talking to a big print dealer who bought my prints because he knew I really made them – I didn't just sign. I had really made them – and I said, 'I don't know why I go to so much trouble; because later on, nobody will know whether it was done by me or by an artisan.' And so he said to me, 'They'll know if you did it, because when painters do their own [print work], it's always screwed up!'"[32] Far from being flawed, Masson's prints are technically superb. But the amusing anecdote underlines Masson's working relationship with his printers and emphasizes the fact that his prints were very much the product of a hands-on approach. His collaboration with printers allowed him to take advantage of the element of chance, which he so highly valued. And in many ways it is Masson's printmaking activity that demonstrates best his ability to work both independently and in collaborative enterprises to achieve his artistic ends — no matter whether he acted "inside" or "outside" Surrealism.

Michael Parke-Taylor

Associate Curator, European Art

# ENDNOTES

1. André Masson, "Le principe d'altération," *Le Plaisir de peindre* (Nice: La Diane française 1950).

2. Deborah Rosenthal, "Interview with André Masson," *Arts Magazine* 55 (November 1980): 89.

3. Jennifer Gibson, "Surrealism Before Freud: Dynamic Psychiatry's 'Simple Recording Instrument.'" *Art Journal* 46 (Spring 1987): 57. This essay discusses how both Breton and Masson developed their ideas about automatism and their understanding of the procedures used by mediums from the methods of Pierre Janet (1859–1947). Janet was a leader in the field of dynamic psychiatry, the principal method for treating the mentally ill before Freud.

4. André Breton, "Manifesto of Surrealism," trans. Richard Seaver and Helen R. Lane, in *Manifestoes of Surrealism* (Ann Arbor: The University of Michigan Press, 1974), 26.

5. Rosenthal, "Interview with André Masson," 93.

6. Michel Leiris in William Jeffett, "Homage to 45, rue Blomet," *Apollo* no. 127 (March 1988): 190.

7. Jennifer Mundy, "Surrealism and Painting: Describing the Imaginary," *Art History* 10 (December 1987): 506.

8. See Laurie J. Monahan's essay in this catalogue for a full discussion of the print project for *Sacrifices,* cf. 65–73.

9. Marko Daniel, "Masson in Spain," in William Jeffett et al., *André Masson: The 1930s* exh. cat. (St. Petersburg, Florida: Salvador Dali Museum, 1999): 26.

10. William L. Pressly, "The Praying Mantis in Surrealist Art," *Art Bulletin* 55 (December 1973): 600–615.

11. Daniel, "Masson in Spain," 33.

12. Other artists who contributed prints to the portfolio included John Buckland-Wright, S.W. Hayter, Dalla Husband, Joan Miró, Pablo Picasso and Yves Tanguy.

13. Rosenthal, "Interview with André Masson," 91.

14. For example, the self-portrait *Improvisation,* 1945 (cat. no. 33), was given its title from the improvisational exigencies of sugar-lift aquatint, which Masson observed at Hayter's when Sue Fuller used Bosco chocolate syrup as a lift ground. See Lawrence Saphire, *André Masson: The Complete Graphic Work,* vol. 1, *Surrealism, 1924–1949.* (Yorktown Heights, N.Y.: Blue Moon Press, 1990), 168.

15. Saphire, *The Complete Graphic Work* 1: 470. Although Masson recalled that he made *Rapt* in 1941, Saphire questioned this date suggesting the print is from as late as 1946. Given the stylistic affinities of the print with Masson's automatic drawings made during his American period, it is difficult to conceive of *Rapt* as a postwar expression.

16. For the relationship of Miró's *Black and Red Series* to the Spanish Civil War, see Deborah Wye, *Joan Miró, Black and Red Series: A New Acquisition in Context* exh. cat. (New York: Museum of Modern Art, 1999).

17. William Rubin and Carolyn Lanchner, *André Masson* exh. cat. (New York: Museum of Modern Art, 1976): 67. Rubin discusses affinities between Masson and Jackson Pollock in William Rubin, "Notes on Masson and Pollock," *Arts* 34 (November 1959): 36–43.

18. The album included prints by Alexander Calder, Leonora Carrington, Marc Chagall, Kurt Seligmann (who was responsible for printing each contribution) and Yves Tanguy, with an altered photograph by David Hare, a poem-object by André Breton, and duplicated drawings by Max Ernst, Matta and Robert Motherwell.

19. Masson first discovered Piranesi in early 1924 and adorned his studio with Piranesi prints of vaulted prisons and instruments of torture.

20. Masson in Roger Passeron, *André Masson: Gravures 1924–1972* (Fribourg: Office du Livre, 1973): 142–43.

21. Saphire, *The Complete Graphic Work* 1: 457

22. Masson in Passeron, *André Masson: Gravures*, 142.

23. Saphire, *The Complete Graphic Work* 1: 160. Saphire notes that Hayter was responsible for printing about twenty prints in the edition of thirty-five, along with a few proofs. Other prints from the edition were later pulls in Paris at Atelier Paul Haasen and Atelier Crommelynck.

24. Lawrence Saphire and Patrick Cramer, *André Masson: The Illustrated Books: Catalogue Raisonné*, translated by Gail Mangold-Vine and Christopher Snow (Geneva: Patrick Cramer, 1994): 58.

25. Masson to Kahnweiler, 19 July 1945. This translation is in Saphire, *The Complete Graphic Work* 1: 180. The original French text is found in André Masson, *Le rebelle du surréalisme: écrits*, ed. Françoise Levaillant (Paris: Hermann, "Collection Savoir," 1994): 274.

26. Saphire, *The Complete Graphic Work* 1: 180. Saphire here refers to Masson's essay "A Crisis of the Imaginary," *Horizon* 12 (July 1945): 42–44. The original French text is found in André Masson, "Une crise de l'imaginaire," *Fontaine* no. 35 (1944): 539–542. Masson's definitive break with André Breton took place in 1943 for political reasons.

27. Saphire and Cramer, *The Illustrated Books*, 78.

28. Saphire and Cramer, *The Illustrated Books*, 84.

29. During his American period, Masson visited The Metropolitan Museum of Art, where he noted Monet's *Cliffs at Etretat*. Masson's meditations on Monet and Impressionism were written in 1952 and published in "Monet le fondateur," *Verve* 7 (January 1953): 68. An interview with Masson on Monet was published in the exhibition catalogue for the Monet retrospective at The Art Institute of Chicago, 1975.

30. Saphire and Cramer, *The Illustrated Books*, 100. The acid biting of the plates was filmed by Jean Grémillon in "La Maison aux Images" (Ateliers Lacourière-Frélaut) in 1955. See Passeron, *André Masson: Gravures 1924–1972*, 156.

31. Roland Barthes, "Sémiographie d'André Masson," reprinted in *André Masson* exh. cat. (Tours: Galerie Davidson, 1973), 5–7. For a complete discussion of Masson and the East, see Françoise Will-Levaillant, "La Chine d'André Masson," *Revue de l'art* no. 12 (1971): 64–74.

32. Rosenthal, "Interview with André Masson," 92.

PRINTING PARADOXES ANDRÉ MASSON'S EARLY GRAPHIC WORKS

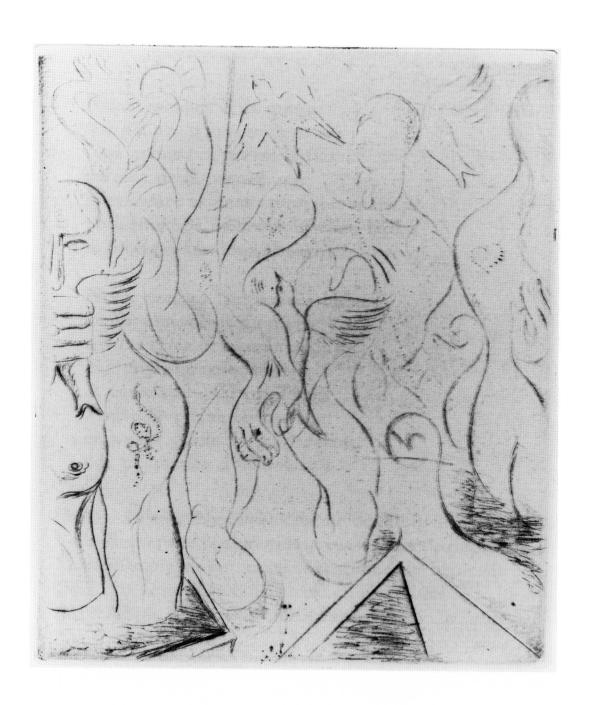

FIG. 27
*Untitled*, 1924
in Georges Limbour, *Soleils bas*

*"The beginning and the end are common on the circumference of the circle."*

—HERACLITUS

ℐN THE YEARS 1924 AND 1925 André Masson produced his first prints, which were used to illustrate books written by his close friends Georges Limbour and Michel Leiris. The images made for these projects were, not surprisingly, closely related to the artist's paintings and drawings of the same period: a blend of symbolic imagery, metamorphosing figures, and sinuous lines meant to suggest the free-flow of thought, rather than preconceived imagery. One might argue that printmaking was simply a logical medium for reproduction, yet I wish to argue here that Masson's engagement with printing techniques was not circumstantial, but integral to the artist's radical politics and specific philosophical interests. This is particularly true of the works preceding World War II, when political and aesthetic strategies were crucial not only to Masson, but to the artists and writers on the Left in the face of burgeoning fascism and impending war throughout Europe.[1]

Yet the viewer may be hard-pressed to name the aesthetic or political project evidenced in prints such as those Masson made for Limbour's *Soleils bas*, where figures and birds intermingle, or where a line indicating an arm also suggests the flight of a bird. One might ask what sense, if any, can be made between works such as these and the prints Masson produced c. 1933, now grouped under the title *Sacrifices*: Mithra is depicted sacrificing a bull; the Minotaur devours a victim; a hapless Orpheus is torn to pieces by the Maenads. This project, engaging as it does themes of tragedy and myth, seems to be at a far remove from the metamorphosing creatures characterized by Masson's earlier works, produced before he left the Surrealist group in 1929. Indeed, if one considers these under the rubric of the radical possibilities implied by the unleashing of the unconscious — a standard trope of Surrealist politics and aesthetics, and one that Masson never entirely abandoned, even after he left the group — it is difficult to forge consistent links and strategies through the works over time. That the artist's works have conventionally been broken down between abstraction (the 1920s, taken up again in the '40s) and figuration (the 1930s) has been another way to cope with these apparent shifts in styles. The prints he produced throughout these periods provide an opportunity to re-examine this trajectory and consider it through the process of printmaking itself. At the risk of posing an irresolvable paradox, Masson's prints might be

described according to a maxim by Heraclitus that the artist was particularly fond of quoting: "As they step into the same rivers, different and (still) different waters flow upon them" — or, more colloquially, "You can never step into the same river twice."[2]

Masson's prints for Leiris's *Simulacre* were lithographs, a medium lending itself to "automatic" drawing, Masson's preferred technique at the time. Putting pencil to paper — or in this case grease crayon to stone — Masson sought to produce drawings that gave visual form to automatism, famously described by Surrealist André Breton as a process "without any intervention on the part of the critical faculties, …unencumbered by the slightest inhibition and which was, as closely as possible, akin to *spoken thought*."[3] Emulating the rush of thought unfettered by the imposition of a rational framework, Masson produced lines that spontaneously metamorphosed across the page, such that a male torso would also be female, that humans would mingle with birds and fish, that a solid classical entablature would reappear as a window onto a limitless desert landscape punctuated by horizon lines (cat. no. 2/fig. 7). Rather than a clear sequence of visual progressions, focused first on one thing and then another, Masson's imagery never clearly differentiated singular beings, but rather was conceived as a continuous flow in which many elements are perceived at the same time: a nipple is also an eye, a navel a breast and a bird, an arm is at once a fish. This doubling carried over into compositional considerations as well: where horizontal lines form a classical entablature in the lower right of the print, they reappear in the upper left corner as horizon lines in some kind of fantastic landscape, as if one was looking over a wall into another world. What is solid in one space becomes transparent elsewhere in the image. The curvilinear forms of a fish with a human eye are mirrored directly below it, but the nearly identical shape indicates a tuft of hair in the armpit of the figure. At once one thing and another: as suggested by Leiris's title, *Simulacre*, appearances are only phantoms presenting themselves as reality. Masson's representations strive to convey the instability inherent in locating the "real."

Undercutting and disrupting conventions of "reality" as a means of disturbing, if not defeating, the status quo was a central tenet of Surrealism. Masson's investment in this project was evidenced through his use of automatism, a process meant to convey how the mind, casting aside the constraints imposed by civilization, could produce images capable in their turn of inspiring conscious radical thoughts and action. He expanded the process by stressing *becoming* rather than *being*; he did this not only through the active technique he employed but also through the generative figures in his images, thereby pointing to the heterogeneous, unstable quality of that which we imagine we *know*. Masson emphasized the metamorphosing qualities of what would otherwise be coherent objects, thus directing attention to the ways in

which the world coheres — not as an empirical, visible reality that implies some kind of objective "truth" but rather as an evolving, even tentative, subjective construct. As Masson himself stated in 1961 when speaking of his engagement with Surrealism, his interest

> consisted in the pursuit, the research, or more exactly, the discovery of *a movement which becomes attached to itself* completely by agreeing to bear its [own] elementary tumult...some irrational vestiges of a recognizable world: those of the elements and the [animal] kingdoms, followed here and there by fragments of human décor. A constellation.[4]

In the images he produced, singularity was subsumed to the relational, and positionality always contingent on and established through reciprocal connections.

This attempt to subvert the coherent, rational unity of the subject was of course not a formal exercise; it inhered a politics as well, a politics deeply invested in the radical possibilities posed in attack on the rational underpinnings of bourgeois culture. For Breton, leader of the Surrealist group, the central inspiration for this task was Freud: by accessing and revealing the unconscious, one could ostensibly release a critical tool that bourgeois culture made every effort to repress and forget. Without discounting the influence of Freud, Masson's trajectory was somewhat different. For while the continuities between forms certainly invited comparison to the free-association of thought, the doubling, amorphous and ambiguous images featured in such prints as those that appear in *Simulacre* are indicative as well of an inquiry into that which suggests appearance and reality, and how — if at all — these are different or the same (compare, for example, figs. 27 and 28). Masson was never interested in literally depicting dreams, but instead sought ways to explore visually the instability and fragility of existence and knowledge as they were mediated through subjective experience. This investigation grew not only from his contact with Surrealism and the writings of Freud, but also from his interest in the writings of Heraclitus, the pre-Socratic philosopher,[5] whom Masson counted among his greatest philosophic inspirations.[6] This connection has been overlooked in discussions of Masson's work in spite of the artist's insistence that the ancient philosopher occupied a central place in his creative production.

In a letter to Leiris, dating from about 1924, Masson wrote, "The secret of painting is in the knot of a cord, whether that knot has been cut by Alexander or Pablo Picasso. Praise be to God, it's always renewed and reknotted by the poets.... Let's not be like Alexander — let's not cut anything, let's always untie and retie new knots, thinking of old Heraclitus."[7] Definitive and final gestures are rejected in lieu of ongoing investigation: once unpacked, the project is less "resolved" than transformed and set in motion again. The desire is not for

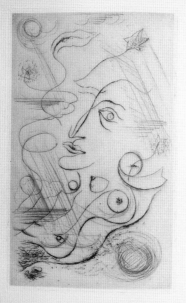

ROBERT DESNOS

# C'est les bottes de 7 lieues
# Cette phrase "Je me vois"

ILLUSTRÉ D'EAUX-FORTES

PAR

ANDRÉ MASSON

ÉDITIONS DE LA GALERIE SIMON
29 bis, Rue d'Astorg — PARIS-VIII'

FIG. 28
*Untitled,* 1926,
in Robert Desnos, *C'est les bottes de 7 lieues.*
*Cette phrase "Je me vois"*

resolution, but rather for engagement, leaving aside the question of outcome altogether. Strands are meant to be conjoined, reconfigured and posed anew, thereby privileging the *process* as much as a product. In this sense, the process of production – so central to Masson's work – came as much from Heraclitus as it did from Freud.

Leiris would echo these sentiments as he grappled with his own creative stakes and purpose in writing:

> As for me, I have the impression that a kind of revolution is being produced within me – from a turning movement in which my thought seems to follow a partial circle, and thus comes back face to face with itself…. It is this which one should be able to reproduce at will…. Such a state corresponds less to the dispersion of the self in the exterior world, rather than the concentration of the exterior world in me. Nevertheless, more than a return from the periphery to the centre, there is identity – without movement in any sense – between the periphery and the centre.[8]

The idea of somehow embodying both an internal and external realm, of being within and without, of somehow unifying positions thought to be mutually exclusive – these were central to Masson and Leiris's creative projects. There is in this a utopic element, one that longs for a world in which contradiction can be comprehended and internalized without ever conflating this with a notion of "mastery" per se. Indeed, key to this understanding is the continuous play of ambiguity and contradiction, where relations are never static. That which becomes fixed is no longer infused with potential – the radical potential that promised to break free of social constraints.

In the Heraclitean universe, the world is composed of many distinct things or a whole, neither of which can be separated. An individual cannot be prised apart from the world, just as the world as a totality cannot stand without the parts comprising it, or, as he put it:

> Things taken together are wholes and not wholes, something which is being brought together and brought apart, which is in tune and out of tune; out of all things there comes a unity, and out of a unity all things.[9]

The world is a series of fragments that find their order both as a unity and as separate, disparate components. Fundamental to Heraclitus's epistemology is the idea of unity in opposites – the fact that things can only be considered on the basis of interrelationships, and what is fundamental to the world is *becoming* rather than *being*. The active state that animates the world resides not only in single, individual perception, but also in the ways that an object can be transformed based on the perspective from which it is considered; thus "a road up

and down is one and the same road,"[10] or "Sea water is very pure and very foul water — for fish drinkable and life-sustaining, for people undrinkable and lethal."[11] Heraclitus's thought points less to a simple duality of objects than the relational structures that produce them: interplay and dispersion, unity and plurality. While duality is allowed, it is never imagined as a binary system in which oppositions are clear and distinct. Rather, unity comes through the presence of potentially conflictual qualities that can coexist without becoming self-contradictory.

The world Heraclitus described is not a static one, in which harmony is always maintained, since he insisted that forces act upon each other with different effect. Rather than positing a world of pure relativity among objects, where coexistence is based on a fundamentally equal distribution of power, Heraclitus argued that the interaction of powerful forces was an essential quality of all living things, and that these forces often inflicted great damage. The contradictory dynamics contained in a single object — as in sea water, for example — could be applied to the world as a whole. Thus the philosopher noted, "War is the father of all, king of all: some it shows as gods, some as human; some it makes slaves and some free."[12] Conflict produces opposites, which although potentially opposed, also serve to create structure — in other words, if war and more generally discord undermines worldly structures by creating disunity, the dynamics set into motion also generate structures that can have the opposite effect of producing order. That these will continuously play against each other is to assure that nothing is ever fixed, but rather dynamically changing even under the most pressing circumstances. Recall that, according to Heraclitus, "one can never step into the same river twice." Feet may always get wet, but always differently, since the water is moving and never the same.

It is precisely this Heraclitean ideal that Masson's engagement with printmaking captures so well, since it meshes his philosophical interest with material practice in specific ways. Always interested in destabilizing conventions and categories, the artist could convey this through the actual processes of print production: what is distinctive as a singular print is at the same time one of many, and what is ostensibly a copy is at the same time an original in its own right. Printmaking hinges on differentiation and unity, from the numbered print to the plate from which each individual impression is taken. The medium speaks to repetition and process rather than beginnings and ends. More metaphorically, creative and destructive forces are at work as well, since the creation of the image is inextricably linked to the continuous deterioration and ultimate destruction of the plate from which it materializes. And, in all of these cases, nothing is purely distinct or opposed; rather, it is its relational quality

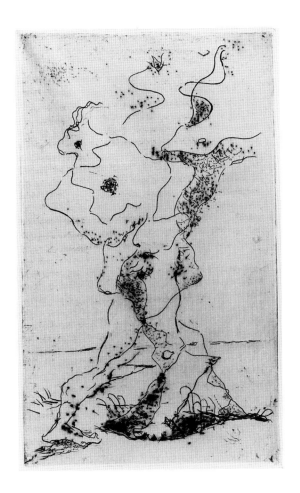

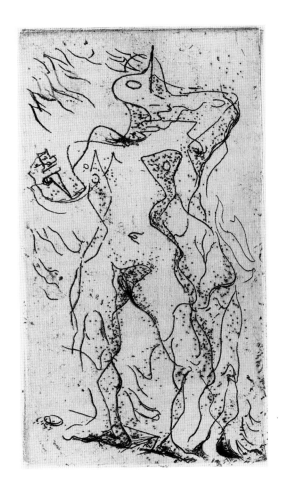

FIG. 29

*Untitled*, 1927

in Marcel Jouhandeau,

*Ximenès Malinjoude*

FIG. 30

*Untitled*, 1927

in Marcel Jouhandeau,

*Ximenès Malinjoude*

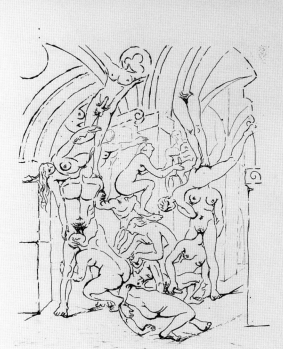

... une reconstitution de la cathédrale de Chartres sans oublier une seule ogive (page 20)

CAT. NO. 5 / FIG. 31

*Untitled*, 1927,

in Louis Aragon (published anonymously),

*Le con d'Irène*

that makes the print — ironically enough — unique as a means of representation. It is as though the medium of printmaking calls forth a variant on Heraclitus's aphorisms: there is a unity of opposites from the original to the copy, the singular to the many, and so on. Each depends on the totality in order to establish singularity and uniqueness as well as an overall coherency.

This theme is carried over into the content of the images as well. In the prints Masson produced for *Ximenès Malinjoude* (1927), a novel written by Marcel Jouhandeau, figures materialize out of intersecting and interconnected lines, making clear distinctions impossible to ascertain. A single plate might suggest an embrace or a violent struggle (see figs. 29 and 30). Even where the figures become highly differentiated, as in the case of those appearing in Louis Aragon's anonymously published erotic novel, *Le con d'Irène* (1928), they quite literally are fitted together like puzzle pieces depicting a sexual bacchanal. Accompanying one such image (cat. no. 5/fig. 31), Masson included an excerpt from Aragon's text: "...a reconstitution of the Cathedral of Chartres without forgetting a single rib."[13] The text underscores the structural underpinnings of the image both in terms of its content and form. As bodies twist and turn, contorting in a variety of sexual poses, they quite literally merge with each other and the architectural structure framing the composition, as seen in the figures who merge with the spandrels of the ribbed arches. At the left of the composition, where the arch terminates into a stone wall, a female figure is shown perpendicular to the male figure below her; her extended arm becomes his, while his head is formed from the lines of her thighs, and so on. Aragon's text serves as the perfect foil for such doubling, a fact that Masson undoubtedly recognized when he chose for his final print the following text: "*Ca ne fait rien, c'est quelque chose, l'amour d'Irène*" (It's nothing, it's something, Irene's love). Playing on the phonic similarities between *rien* (nothing) and the name of the *heroine*, Irène, Aragon asserts that it's both nothing and something, just as the figures and phalluses above alternately coalesce into things, and then fragment into nothing but a cacophony of lines.

These early works from the 1920s signal themes that would continue to appear throughout Masson's work: overt sexual content, struggle and death, which were only implied in works from Limbour's *Soleils bas,* for example, but became much sharper over time. In the images for Jouhandeau's *Ximenès Malinjoude,* the violence grows progressively more evident and in the early etchings of the 1930s, such as *L'homme au couteau (Massacre),* c. 1933 (cat. no. 7/fig. 32) and *Massacre,* c. 1933 (cat. no. 8/fig. 33), it is finally made into the subject of the prints themselves, with little or no ambiguity. What is increasingly privileged is a world of violence — often sexualized, as in the case of the *Massacre* etchings. These developments paralleled Masson's

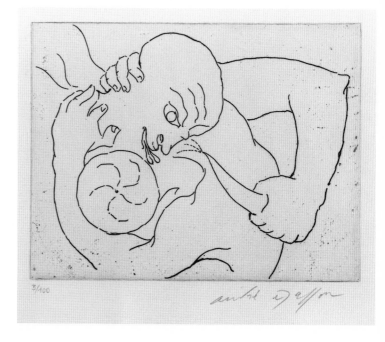

<p style="text-align:center">CAT. NO. 7 / FIG. 32</p>
<p style="text-align:center"><em>L'homme au couteau (Massacre)</em>, 1933</p>

<p style="text-align:center">CAT. NO. 8 / FIG. 33</p>
<p style="text-align:center"><em>Massacre</em>, c. 1933</p>

subject matter in other media as well, particularly in drawing, and would seem to indicate that the oscillating world of unity in opposites, at least as it was ambiguously pictured in the 1920s, had made a definitive exit with the onset of the 1930s.

That this was not the case is indicated in a comment Masson made to Leiris in a letter dating from December 1926. There he expressed issues that would haunt his work in the following decade:

> For me there's nothing else but to consent to being at once the prey and the shadow. On another order of ideas (or the same) — the most distressing abyss has always been for me this thought — that it seems impossible to be both the sacrificed and the executioner at the same time.[14]

Here Masson begins to mull over strategies and positions in particularly Heraclitean terms. His letter speaks of a relationship between the appearances of things and their presumed material existence, discounting any sense of privileging one over the other. Playing on the French adage of "leaving the prey for the shadow," or abandoning a certain advantage for vain hope, Masson seems to embrace the confusion between the two, in a paradox worthy of Heraclitus's own pen. Can holding the advantage and clinging to vain hope be at once one and the same thing? What would it mean to simultaneously occupy the subjective positions of executioner and sacrificial victim? Could it be possible to occupy this completely impossible territory, and why would it be vitally important to do so? It seems that while Masson posed the problem to Leiris late in 1926, his first full-scale project that aimed to address the issue came about in 1933–34, when he began a series of drawings and then prints, which he called *Sacrifices* (cat. no. 12 a-e).

This was arguably Masson's most ambitious print project, conceived first as images, and then as a collaborative project with a text offered by his close friend, the writer Georges Bataille. It was clearly something that Masson cared about deeply: related drawings were exhibited at his one-person show at the Galerie Jeanne Bucher in 1931–2, and the prints themselves preoccupied Masson until 1936, when they were finally published.[15] Five etchings, each representing a figure who suffered a violent death, were produced for the project: *Mithra, Orphée, Le crucifié, Minotaure* and *Osiris* (figs. 34, 35, 36, 37, 38, respectively). Bataille's text had no direct connection to Masson's prints, reflecting as it did on the sacrifice implied by subjective *being* in the world rather than specific myths of sacrifice. Thus both contributors addressed the issue of sacrifice, but in complementary ways: the material examples of sacrifice through Masson's images were amplified through Bataille's abstract discussion of the nature of subjectivity itself.[16] Thus the images for *Sacrifices* were not illustrative of or even supplements to the text, but were conceived as a central, primary element of the collaborative effort. The project, comprising text and sepia etchings, was entitled *Sacrifices: Les Dieux qui Meurent* (The Gods who Die). The title was based on J.G. Frazer's work of the same name, an excerpt from his book *The Golden Bough*, which had recently been translated into French. Frazer addressed the ritual sacrifice of various gods or kings in religious practices of "primitive" people and mythic history in general. The book provided a wealth of mythic examples and themes, which occurred and occasionally recurred across cultures; it was avidly read by Bataille and was certainly well known to Masson, whose prints depict gods described in Frazer's text.[17]

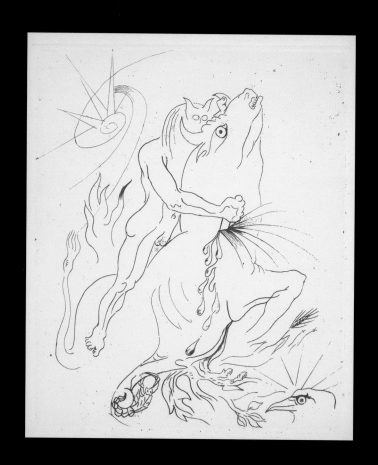

CAT. NO. 12a / FIG. 34

*Mithra*, 1936,

from Georges Bataille, *Sacrifices*

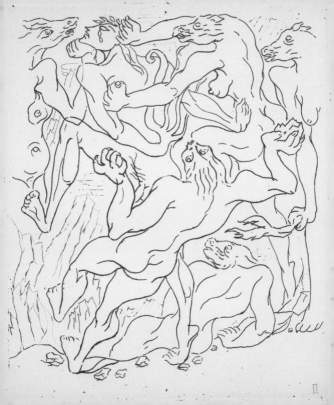

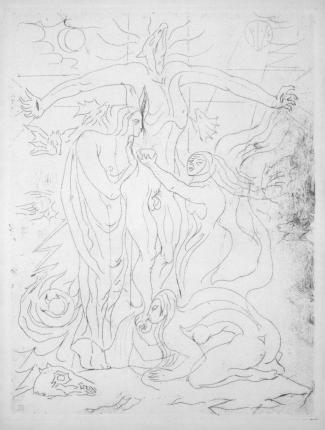

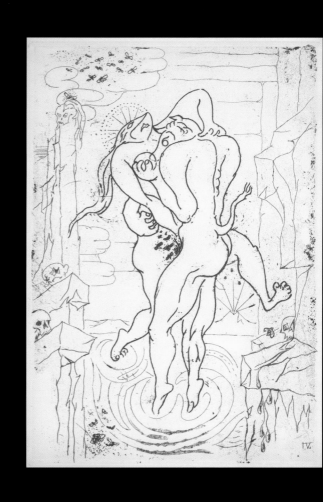

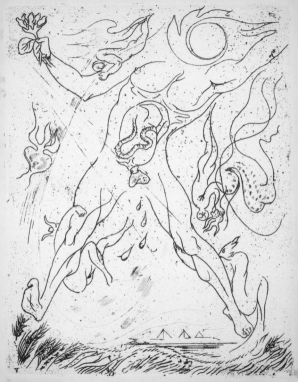

Masson's etchings, in all but two instances, show the central characters at the moment of their deaths: Osiris, the Egyptian god, was said to have been murdered by his brother Typhon who, upon hearing that the god's body had been found, set upon it again and dismembered it. Orpheus suffered a similar fate at the hands of the Maenads, who, enraged by his arguments against sacrificing to Dionysus, tore him apart. The "Crucified One" obviously evokes the image of Christ, although here he is replaced by a creature who has a human body but the head of an animal. The women gathered around him lasciviously collect his blood, one lapping it up at his feet, while a male figure to the left licks the open wound in the victim's side. Mithras is one of the exceptions to "the gods who die" in Masson's series: depicted as a creature plunging a knife into the chest of a bull, Mithras performs the sacrifice that became central to his followers, according to Frazer.[18] According to legend, Mithras was ordered by the sun to slaughter a bull, which he did reluctantly. Once dead, the beast's corpse produced all manner of things on the earth, and thus Mithras "became the creator of all the beneficent beings on earth; and, from the death which he had caused, was born a new life, more rich and more fecund than the old."[19] Similarly Masson has not chosen to depict the Minotaur dying at the hands of Theseus; instead he represented the hybrid creature in the act of attacking one of the victims sacrificed to him regularly. The beast hovers over his female victim, seeming to rape her and devour her simultaneously.

The issue of sacrifice itself is crucial in these images, whether this is a fate of a god or mere mortal creature. Taken as a totality, the images represent both the sacrificed and the executioners — but this wasn't simply a literal transcription of Masson's wish to unite the two states by cataloguing occurrences where they appeared, alternating one with the other. Instead, conjoined by the theme of sacrifice, they seem to index the potential loss of clear, subjective spaces undermined by the dual character each participant in the sacrifice represents. Whether executioner or victim, each is poised at the demarcation between the sacred and profane. According to sociologists Henri Hubert and Marcel Mauss, whose influential work on sacrifice (1898) was known to Bataille and Masson, the one who performs the sacrifice "stands on the threshold of the sacred and the profane world and represents them both at one and the same time. They are linked in him."[20] The victim shares an equally ambiguous status, since the preparations for sacrifice have sanctified her/him, so that "the divine principle, which it [the victim] now contains, is still pent up in its body and attached by this last link to the world of profane things. Death will release it, thereby making the consecration definitive and irrevocable."[21]

The sacred and profane worlds are united for a brief instance just prior to the completion of sacrifice, when the victim is dispatched to the realm of the sacred through the act of the executioner. It is an impossible, inconceivable space, one which produces "a dismembering of structures in which one consciously exists and knows himself or herself. Standing out from oneself — ec-stasis — occurs in an event of disjoining and falling apart. In such an event, 'that' which 'Dionysus' signifies [e.g., uncontrolled and uncontrollable desire] becomes vivid, although 'it' is without an image to preserve it."[22] It is in this "nowhere land" that a self can be radically altered, but the form it will take is unclear, for it is only the potentiality of transformation that can be pictured — anything else remains in the realm of mere appearances rather than genuine existence.

In the sacrifice each figure complements the other — not in order to create harmony, but rather to generate the force that has both creative and destructive potential.[23] As figures on which society has conferred considerable power, the executioner and victim occupy a liminal space in which boundaries are necessarily elided. Their diametrically different roles appear to separate them, but they are united through their structural purpose, which is identical: both engage with death, in order to generate life through the protection of the cultural order they collectively represent through their singular positions. It is this position — which cannot be contained or sustained through a singular subjectivity — that Masson longed to occupy, for it is there that this loss of self is fused with tremendous collective potential.

Without this potential, the self is locked into isolation, both metaphorically and psychically, as Bataille noted in the opening paragraph of his accompanying text: "*Me,* I exist — suspended in a realized void — suspended from my own dread — different from all other being and such that the various events that can reach all other being and not *me* cruelly throw this *me* out of a total existence."[24] The unique character of the subjective self — here distinguished from all others — derives its awareness through its exclusion from total existence. It is as if the boundaries necessary to delimit experience also deprive the subject of a *fully* lived experience, one shared with others. Singularity does not come without its price, but neither does its radical reconfiguration, possible only through a violence that affects both individual and collective consciousness. In the case of Bataille's text, this process is discussed through individual subjectivity and its relationship to the world at large. In Masson's prints, this process is suggested through the dual nature implied by sacrifice and its protagonists' relations to the social, where executioner and victim are situated between the profane and the sacred worlds. The sacrifice itself becomes the process that mediates these two states.[25]

This process is complemented by Masson's own relationship to the prints themselves — through the violence of literally attacking the plate, cutting into it, Masson destroys portions of the surface in order to create the image. While one might argue that this is the necessary condition for the production of any etching, Masson's always self-conscious relationship to process gives the bleeding etched lines added resonance.[26] Substance removed, the shadow emerges — that which, through its material absence, allows for the appearance of the representation — itself only a cipher waiting to be reactualized as image on paper.

The tentative shared qualities of Masson's earlier, metamorphosing images has, by the time of the *Sacrifices* project, been rewritten into figurative language, which produces a more metaphoric strategy of engaging issues of subjectivity, appearance and the "real." It is almost as though Masson has reversed his strategies of representation, making the abstract concept over into finite forms rather than suggesting instability through the forms themselves.

It is here that Heraclitus reappears, since sacrifice — as a social activity that engages both appearances and material reality without privileging one over the other — embodies the unity of opposites. This is never imagined as an exclusively harmonious unity, but rather hinges on the *process* of interaction and interrelationships, which themselves form and reform the world. The dynamic force produced through these encounters result in things positive and negative, or to recall Heraclitus's terms, "some it shows as gods, some as human; some it makes slaves and some free." That this view might modify and also reinforce Masson's bleak measure of the contemporary situation is attested to by a letter the artist addressed to Bataille in October of 1935. There he rejects Marxism as a potential revolutionary strategy because

> its bases are uniquely rational and utilitarian and [Marx] obstinately rejected everything which wasn't: Reason, Output, Work…(even pleasure must be useful)…. The class struggle will produce a society without classes? But that's ridiculous — There will always be classes, a hierarchy, prisons and prisoners, oppressors and oppressed…. Men always remain separated from their passions, even if they're commissars of the people…. Stupidity of Marx when he wanted to create a Society without myths.[27]

Concerned that the material focus overlooked the drives that motor desire, Masson was not advocating social inequality, but rather looking for ways in which desire could be acknowledged within a radical framework. What myth, and more indirectly but no less profoundly, the Heraclitean philosophy posed was a way of thinking about the nature of things, in both material and metaphysical terms. The kind of fatalistic pessimism Masson expressed in the

darkest days of the 1930s was offset by the conviction that through the shadow which stalks substance — those intangibles embodied through myth and desire — one might come closer to understanding and comprehending the contradictions implicit both inside and outside of culture.

That this would continue to haunt Masson's future work is attested to by the text and images included in his *Anatomy of My Universe*, a project begun around 1938 but not published until 1942, when Masson was living in the United States. This project — which included his etching *Signes* (cat. no. 30/fig. 39) in the deluxe copies — was the most extensive commentary that Masson produced on his own work in his lifetime. Echoing the sentiments he had expressed to Bataille about the problems of an exclusively rational approach to the world, he stated:

> I let my reason go as far as it can. It traverses the court of objects and reaches finally a waste-land of infinite desolation; it is a truly human place, which creates its own Time. Here, a prisoner escaped from Plato's cave, I shall no longer be subject to his condemnation of imitated reality. I would be only a point of intersection, a magnetic needle, a medium. Yet in this desert of being, where nothing can distract me, I shall realize whatever I imagine — whatever I dispose of Possibility.[28]

It seems fitting that Masson would liken himself to an intersecting point that comes into being when others pass through it. His own creative state is that which depends on its relational quality, unique and at the same time defined by its position vis-à-vis others. A needle, a point, a medium: a print, a trace of the possible at a particular time, always experienced and appearing differently, like the river which can never be stepped in the same way twice.

Laurie J. Monahan
UNIVERSITY OF CALIFORNIA,
SANTA BARBARA

CAT. NO. 30 / FIG. 39
*Signes*, 1942,
in *André Masson,*
*Anatomy of My Universe*

andré masson

# ENDNOTES

1. A few historical details are instructive here: In 1922 Mussolini's fascist regime was established in Italy; by 1933 Hitler had taken control in Germany. From 1929 to 1934 France would see eleven ministries fall in rapid succession, culminating in serious riots in 1934, when paramilitary groups threatened to storm the Assemblée nationale. While the leftist Popular Front government was established in 1936 in France, it was short-lived and relatively weak internationally, unwilling to rally support for the Spanish Republic, and unable to challenge effectively the fascist movements threatening its borders. Against these historical developments, the Left in France, divided ideologically and tactically throughout the 1920s and 30s, complicated the kinds of aesthetic decisions made by artists. The Surrealists' problems with the Communist Party, which by 1932 were solidly behind social realism, was but one example of the difficulties artists on the Left faced in negotiating politics through their work.

2. Heraclitus, *Fragments,* text and trans., T.M. Robinson (Toronto: University of Toronto Press, 1987), 17 (fragment 12). This phrase and its more informal rendering is actually of dubious origin relative to the surviving fragments of Heraclitus's writings. For Masson's use of the phrase, see, for example, his letter to Maurice Loutreuil, 16 May 1918, in *André Masson, Correspondance 1916-1942,* ed. and annotated by Françoise Levaillant (Paris: La Manufacture, 1990), 20.

3. André Breton, "Manifesto of Surrealism," in *Manifestoes of Surrealism* (1924), trans. Richard Seaver and Helen R. Lane (Ann Arbor: University of Michigan Press, 1972), 23.

4. The emphasis is Masson's. See André Masson, "Propos sur le Surréalisme," *Médiations* no. 3 (Fall 1961), reprinted in André Masson, *Le rebelle du surréalisme,* ed. Françoise Levaillant (Paris: Hermann, 1976): 35. Unless otherwise noted, translations are mine: "*consistait en la poursuite, la recherche, ou plus exactement la trouvaille* d'un mouvement qui s'éprend de lui-même *tout en acceptant d'emporter dans son tumulte élémentaire… des vestiges irrationnels d'un monde reconnaissable: celui des éléments et des règnes, voire par ci par là, des fragments du décor humain. Une constellation.*"

5. Information about the life of the philosopher is sparse; he lived between the end of the 6th century and beginning of the 5th century B.C.E., and resided in the wealthy city of Ephesus, located in Asia Minor and under Persian rule at that time. See Heraclitus, *Fragments,* introduction, passim.

6. In a letter to Leiris, dating from 25 August 1938, Masson wrote: "In spite of this I persist in believing that the greatest amount of truth remains consistently in Heraclitus, active philosopher, in Paracelsus, and in certain flashes by Nietzsche" (*Malgré cela je persiste à croire que la plus grande somme de vérité reste contenue dans Héraclite, philosophe actif, dans Paracelse, et dans certaines flammes de Nietzsche.*), *Correspondance,* 395.

7. Undated letter (Spring 1924), Masson to Leiris, ibid., 68. "*Tout le secret de la peinture tient dans le nœud d'une corde, peu importe qu'il ait été tranché par Alexandre ou Pablo Picasso. Vive Dieu il est toujours renoué par les poëtes* [sic]*…. Ne faisons pas comme Alexandre ne tranchons rien, dénouons et renouons des nœuds toujours nouveaux en pensant au vieil Héraclite.*"

8. Journal entry, May 1929, Leiris, *Journal, 1922–1989* (Paris: Gallimard/NRF, 1992), 138. (*J'ai l'impression, quant à moi, d'une espèce de révolution qui se produit en moi, – de mouvement tournant dans lequel ma pensée semble décrire un demi-cercle et ainsi se tenir face à face avec elle-même....C'est cela qu'il faudrait pouvoir reproduire à volonté. Un tel état correspond moins à la dispersion du moi dans le monde extérieur qu'à la concentration du monde extérieur dans moi. Toutefois, plus que retour de la périphérie au centre, il y a identité – sans mouvement dans aucun sens – entre la périphérie et le centre.*)

9. Heraclitus, Fragment 10, *The Presocratic Philosophers*, trans. G.S. Kirk, J.E. Rave, N. Schofield (Cambridge: Cambridge University Press, 1983; 1st edition 1957), 190.

10. Ibid., Fragment 60, 41.

11. Robinson, Fragment 61, 41.

12. Heraclitus, Fragment 53, quoted in Richard D. McKirahan, Jr., *Philosophy Before Socrates* (Indianapolis/Cambridge: Hackett Publishing, 1994), 106.

13. The text as it appears on the plate reads: "*une reconstitution de la cathédrale de Chartres sans oublier une seule ogive.*" (page 20)

14. Letter to Leiris, 21 December 1926, Masson, *Correspondance,* 130. Masson references the phrase "leave the prey for the shadow" ("*laisser la proie pour l'ombre*") e.g., to abandon a certain advantage for a vain hope, an allusion to the fable by La Fontaine. ("*Pour moi il n'y a rien d'autre à consentir qu'être à la fois la proie et l'ombre. — Ce qui ne veut rien dire. Dans un autre ordre d'idées (ou le même) — Le gouffre le plus angoissant m'a toujours été cette pensée qu'il paraît inaccessible d'être à la fois le sacrifié et le sacrificateur.*")

15. For the anxiety the project provoked in Masson, along with the chronology of the negotiations to get it published, see Glòria Bosch and Teresa Grandas, *André Masson & Georges Bataille, Complicitats* (Tossa de Mar, Spain: Musée Municipal de Tossa de Mar, 1991), 235–43 and Masson's letters to Georges Bataille, especially 5 September 1934 and 17 January 1936, in *Correspondance*, 212–13 and 306–308.

16. An extensive analysis of Bataille's text for the *Sacrifices* project can be found in my *A Knife Halfway into Dreams: André Masson, Massacres and Surrealism of the 1930s*, (unpublished Ph.D. diss., Harvard University, 1997), chapter 3, passim. See also Françoise Levaillant, "Masson, Bataille, ou l'incongruité des signes (1928–1937)," in *André Masson* (Nîmes: The City of Nîmes/Le Carré d'Art, 1985), 31–41.

17. As an employee of the Bibliothèque Nationale, Bataille was able to borrow books, and library records show that he read and re-read Frazer throughout the 1930s. See Georges Bataille, *Œuvres Complètes* XII, Appendix "Emprunts de Georges Bataille," passim.

18. J.G. Frazer, *The Golden Bough* (abridged) I (New York: Macmillan Publishing, 1963; original text published 1922), 542.

19. Franz Cumont, *The Mysteries of Mithra*, trans. Thomas J. McCormack (New York: Dover Publications, 1956), 137.

20. Henri Hubert and Marcel Mauss, *Sacrifice: Its Nature and Functions*, with a Foreword by E.E. Evans-Pritchard, trans. W.D. Halls (Chicago: University of Chicago Press, 1981), 23. Originally published as "Essai sur la nature et la fonction du sacrifice," *L'Année sociologique* (1898): 29–138.

21. Ibid., 32–33.

22. Charles E. Scott, "Appearing to Remember Heraclitus," in *The Presocratics after Heidegger*, ed. David C. Jacobs (Albany: State University of New York, 1999), 251.

23. For example, if a sacrifice is mishandled — if the sacrifice is not properly prepared or chosen carefully — the collective body — represented by the executioner — risks destruction, or at the very least, a sacrificial crisis in which the social order cannot be maintained. See René Girard's discussion of this phenomenon in his *Violence and the Sacred,* trans. Patrick Gregory (Baltimore: Johns Hopkins University Press, 1979; French edition, 1972), passim.

24. Bataille, "Sacrifices," (1933), in *Visions of Excess: Selected Writings, 1927–1939,* ed. and trans. Allan Stoekl (Minneapolis: University of Minnesota Press, 1985), 136. The text originally appeared as Georges Bataille and André Masson, *Sacrifices* (Paris: G.L.M., 1936). ("Moi, *j'existe, — suspendu dans un vide réalisé — suspendu à ma propre angoisse — différent de tout autre être et tel que les divers événements qui peuvent atteindre tout autre et non* moi *rejettent cruellement ce* moi *hors d'une existence totale.*")

25. This is not to suggest that other issues are not raised by these images; for example, Levaillant has discussed the psychoanalytic implications of these works (see Levaillant, "Masson — Bataille," passim); see also Monahan, "*A Knife Halfway…,*" chapter 3, passim.

26. Masson produced at least one drawing in which the process and actual representation were conjoined quite self-consciously. In a pastel drawing — part of his *Massacre* series — produced at about the same time that he was working on the *Sacrifices* etchings, the artist depicted male figures attacking female victims with knives. He then traced the lines themselves with the tip of a knife, essentially reenacting the scene depicted through the formal cuts into the drawing. The issues of gender and sadomasochism, so vividly raised here, are addressed more fully in Monahan "*A Knife Halfway…,*" passim.

27. Masson to Bataille, 6 October 1935, *Correspondance:* 281–82. ("*…ses bases sont uniquement rationalistes et utilitaires et qu'il rejette obstinément tout ce qui n'est pas: Raison-Rendement-Travail utile…(même le plaisir doit être utile)…. La lutte de classes pour arriver à une société sans classes? mais c'est idiot — Il y aura toujours des classes, une hiérarchie, des prisons et des prisonniers, des oppresseurs et des opprimés…. Les hommes resteront toujours égarés par leurs passions, même s'ils sont commissaires du peuple… Stupidité de Marx quand il veut créer une Société sans mythes.*")

28. André Masson, *Anatomy of My Universe* (New York: Curt Valentin, 1943): section IV, n.p. The translation, while not noted in the text, is by art historian Meyer Schapiro; Masson's original French text has been lost.

André Masson,
c. 1970

## 1896

Born 4 January at Balagny.

## 1903—1906

The family moves to Lille and
then in 1905 to Brussels.

## 1907—1911

Admitted to the Académie Royale des
Beaux-Arts et L'École des Arts Décoratifs
in Brussels. In 1910 sees exhibition of
James Ensor paintings at the World's
Fair in Brussels, which provides a
decisive encounter with Modern art.

## 1912

Sees first Cubist works by Picasso, Braque
and Léger in reproduction in the journal
*Je sais tout.* Dominant style of own painting
is in a Nabi manner. Emile Verhaeren
advises Masson to study in Paris.

## 1913—1914

Enrols at École Nationale Supérieure des
Beaux-Arts in Paris in January 1913. Visits
museums and is impressed by Poussin
among the Old Masters. Sees Matisse
paintings at Bernheim Jeune, but more
interested at time in Puvis de Chavannes.

## 1915—1916

Infantryman in French army. In
1916 sees combat in the Somme.

## 1917

Sustains serious chest injury
in Battle of the Somme.

## 1918

Discharged from army with doctor's
advice never to live in an urban
centre because of war trauma.

## 1920

Marries Odette Cabalé and returns to Paris.
Birth of daughter Gladys (known as Lili).
Parisian dealer Daniel-Henry Kahnweiler
names his gallery after his French associate,
André Simon (Galerie Simon) to avoid
anti-German sentiment.

## 1921

Moves to 45, rue Blomet, where he shares
an adjacent atelier with Miró.

## 1922—23

Through rue Blomet studio meets various
artists and writers including Leiris,
Limbour, Dubuffet, and Salacrou.
Masson develops passion for Nietzsche
and Dostoevsky. Masson is aware of
the first Surrealist group forming
around André Breton. Masson is
offered a contract with Kahnweiler.

## 1924

Breton publishes the first Surrealist
Manifesto, which stresses the technique
of automatism as the generating principle
of Surrealism. Masson meets Breton and
later in the year meets Georges Bataille
through Leiris. Masson executes first
original prints (etchings with drypoint),
which are published by Kahnweiler's
Galerie Simon in a limited edition of
Georges Limbour's poems titled *Soleils bas.*

## 1925

Masson makes first lithographs, which
are published by Galerie Simon in
Leiris's book of poetry *Simulacre.*

## 1926

Masson makes first sand paintings
at Sanary-sur-Mer.

## 1928

Illustrates Louis Aragon's pornographic prose *Le con d'Irène* with sexually explicit prints, which Kahnweiler considers "too realistic."

## 1929

Masson breaks with Breton and the Surrealist group. Masson forms a close association with Bataille and others loosely organized around Bataille's journal *Documents*.

## 1930

Publication of first monograph on Masson by Pascal Pia. Divorces Odette Cabalé. Meets Japanese artist Kuni Matsuo, who fosters Masson's interest in Oriental and Zen art.

## 1931

Masson leaves Kahnweiler and is put under contract with dealer Paul Rosenberg. From 1931 to 1933 Masson produces a series of prints and drawings of violent and erotic subjects known as the "Massacres."

## 1933

Portfolio of five etchings to accompany Bataille's theoretical essay *Sacrifices*. The prints concern the darker myths of the ancient world that were based around themes of sacrifice, sexuality and death. Renews relationship with Kahnweiler after Rosenberg fails to renew contract due to Surrealist "tendency." Makes first prints not intended as book illustrations. Moves to south of France and begins decors for Léonide Massine's ballet *Les Présages*.

## 1934—37

Masson's "Spanish Period."

## 1934

Moves with Rose Maklès to Tossa de Mar, Spain. Masson thoroughly involved with Spanish life and culture. Marries Rose in Barcelona on 28 December.

## 1935

Birth of son Diego Masson, 21 June.

## 1936

Spanish Civil War begins and Masson is involved with anti-fascist position. Beginning of Masson's "second surrealist" period (1936—43) coinciding with reconciliation with Breton and surrealist group. Birth of son Luis, 26 September.

## 1938

Contributes etching to an album entitled *Solidarité* to assist Spanish orphans during the Civil War.

## 1940

War forces the Massons to take refuge in Marseilles. Kahnweiler changes name of his galerie from Galerie Simon to Galerie Louise Leiris. By transferring his gallery holdings to Louise Leiris, daughter of his wife (and married to Michel Leiris), Kahnweiler prevents confiscation by the Nazis.

## 1941—45

Nazi occupation leads to Masson's "American Period."

## 1941

With help from Varian Fry of the America Rescue Committee, the Massons sail to Martinique enroute to New York. Stay with Georges Duthuit and his wife, Marguerite Matisse (daughter of the artist), in New York. Settle in New Preston, Connecticut. Represented in America by the dealer Curt Valentin of the Buchholz Gallery, New York. Masson visits Museum of Fine Arts, Boston, where he pays particular attention to Chinese painting, which proves a rich source for much of his work from 1944 to 1960. Begins his association with Stanley William Hayter's Atelier 17 in New York, where he makes most of his prints during his American sojourn. Also prints with Kurt Seligmann upon arrival in United States.

## 1942

At Atelier 17 makes the etching and drypoint *Rêve d'un futur désert* (Dream of a Future Desert), which becomes his most ambitious print in scale and subject.

## 1943

Definitive break with Breton in 1943 for political reasons. End of Masson's "second surrealist" period.

## 1945

At the end of the war the Massons return to France, settling near Poitiers. Exhibits work in Paris at Kahnweiler's gallery, known as Galerie Louise Leiris since 1940. Makes 12 lithographs for the album *Bestiaire*, his major graphic book in America and first comprehensive illustrated book with

original prints since the 1933 portfolio *Sacrifices*. Commissioned by Edvard de Rouvre to illustrate Coleridge's *The Rime of the Ancient Mariner*, *Christabel* and *Kubla Khan*.

## 1946

Masson in contact again with master printers Lacourière and Frélaut, with whom he prints etchings. *Portrait d'Emily Brontë* is Masson's first colour lithograph using two plates. *Caprice villageois* is Masson's first colour drypoint.

## 1947

The Massons move to Le Tholonet near Aix-en-Provence. Works at atelier Mourlot. *Hespéride* is Masson's first lithograph to deploy more than two colours.

## 1948

Inspired by Impressionism of Monet and interest in Turner, Renoir, Cézanne and Zen Buddhism. Returns to inspiration of Chinese painting and calligraphy first seen at the Museum of Fine Arts, Boston, in 1941. Meets printer Léo Marchutz.

## 1949—50

Prints first colour etchings (33) for one of his most important *grands livres illustrés*: André Malraux's *Les conquérants*. Works with Marchutz at the Château Noir, his lithographic studio near Aix. Makes lithographs on rice paper.

## 1951—52

Travels to Italy, his first visit since 1914. For the next three years he returns to Italy, and during that time works on his important book of colour lithographs, *Voyage à Venise*, published in 1952. Uses transfer paper to make lithographs *sur le motif*, a technique learned from Marchutz.

Also learns from Marchutz how to make colour lithographs from a single pull instead of using a different stone for every colour as in traditional colour lithography.

## 1954

Continues to work at Le Tholonet with Marchutz on lithographic albums dealing with aspects of nature.

## 1955

Colour etchings at Lacourière-Frélaut for illustrated book by Jean Paulhan, *Hain-Teny*. The technical innovation of these etchings involved the use of multiple relief plates inked simultaneously for all colours to give not only a visual richness, but one that created a tactile experience from smooth to rough textures. The result is one of the most important books Masson illustrated in etching (published 1956).

## 1956

Colour etchings and aquatints for *Féminaire*.

## 1957

Lives for most of the year in Paris. First etchings with the Atelier Crommelynck. Roland Barthes refers to Masson's work as "semiography" due to the appearance of calligraphic forms ultimately derived from Chinese or Japanese ideograms.

## 1958

The Graphische Sammlung Albertina in Vienna organizes first retrospective exhibition of Masson's prints.

## 1963

Moves to 26, rue de Sévigné, Paris. Retrospective of etchings and lithographs at Galerie Gérard Cramer, Geneva: *Le monde imaginaire d'André Masson (1934–63)*.

## 1973

Publication of Roger Passeron's important book on Masson's prints: *André Masson. Gravures 1924–1972*.

## 1976

Major retrospective of Masson's career at the Museum of Modern Art, New York, with substantial catalogue by William Rubin and Carolyn Lanchner.

## 1977–85

Continues to make prints.

## 1987

28 October, dies at home in Paris.

## 1990

Publication of first volume of catalogue raisonné of Masson's graphic work by Lawrence Saphire: *Surrealism, 1924–1949*.

## 1994

Publication of the catalogue raisonné of Masson's illustrated books by Lawrence Saphire and Patrick Cramer.

The chronology is indebted to the following sources:

Duby, Georges. *André Masson: Nature's Delirious Wisdom*. Exhibition catalogue. Aosta, Italy: Museo Archeologico, 1995.

Jeffett et al. *André Masson: The 1930s*. Exhibition catalogue. St. Petersburg, Florida: Salvador Dali Museum, 1999.

Rubin, William, and Carolyn Lanchner. *André Masson*. Exhibition catalogue. New York: Museum of Modern Art, 1976.

# LIST OF WORKS

S. numbers and S. & C. numbers refer to the catalogue numbers from the following two catalogues raisonné of Masson's graphic oeuvre:

Saphire, Lawrence. *André Masson: The Complete Graphic Work*. Vol. 1, *Surrealism, 1924–1949*. Yorktown Heights, N.Y.: Blue Moon Press, 1990.

Saphire, Lawrence, and Patrick Cramer. *André Masson: The Illustrated Books: Catalogue Raisonné*. Translated by Gail Mangold-Vine and Christopher Snow. Geneva: Patrick Cramer, 1994.

Passeron numbers refer to: Passeron, Roger. *André Masson: Gravures 1924-1972*. Fribourg: Office du Livre, 1973.

All works are in the collection of the Art Gallery of Ontario, gift of Allan and Sondra Gotlieb, 1999, unless otherwise noted. The order of works in this listing conforms to the sequence of Saphire's numbers in the catalogue raisonné.

ANDRÉ MASSON

**b. Balagny, France, 1896; d. Paris, 1987**

1.
*Untitled*, 1924
Etching with drypoint on Arches laid paper
25.3 x 19.7 cm
Georges Limbour, *Soleils bas*
(Paris: Galerie Simon, 1924)
Copy 47/100
Signed in ink by the author and artist
Printer: Imprimerie Charlot Frères, Paris
S. 3 (p. 13); S. & C. 1
99/764.3

2.
*Untitled*, 1925
Lithograph on Arches laid paper
25.4 x 19.8 cm
Michel Leiris and André Masson, *Simulacre* (Paris: Galerie Simon, 1925)
Copy 71/100
Signed in ink by the author and artist
Printer: Imprimerie Pitault, Paris
S. 8 (p. 15); S. & C. 2
99/765.4

3.
*Untitled*, 1926
Etching on Arches laid paper
33.0 x 24.6 cm
Robert Desnos, *C'est les bottes de 7 lieues. Cette phrase "Je me vois"*
(Paris: Galerie Simon, 1926)
Copy 56/100
Signed in ink by the author and artist
Printer: Imprimerie Charlot Frères, Paris
S. 12 (frontispiece); S. & C. 3
99/766.1

4.
*Untitled*, 1927
Etching on Arches laid paper
17.5 x 13.2 cm
Marcel Jouhandeau, *Ximenès Malinjoude*
(Paris: Galerie Simon, 1927)
Copy 20/100
Signed in ink by the author and artist
Printer: Imprimerie Charlot Frères, Paris
S. 19 (p. 49); S. & C. 4
99/767.4

5.
*Untitled*, 1928
Etching on Arches laid paper
24.7 x 19.4 cm
Louis Aragon (anonymous), *Le con d'Irène*
(Paris: Anonymous editor, 1928)
Copy 120/135
Unsigned (dedicated by Masson to Camille Aboussouan on first title page)
Printer unknown
S. 23 (opp. p. 16); S. & C. 5
99/768.2

6.

*Untitled*, 1931
Drypoint on Arches wove paper
25.1 x 19.7 cm
Georges Bataille, *L'anus solaire*
(Paris: Galerie Simon, 1931)
Copy 75/100
Signed in blue pencil by the author
Printer: Imprimerie Charlot
Frères, Paris
S. 35 (p. 7); S. & C. 7
99/769.1

7.

*L'homme au couteau (Massacre)*
(Man with Knife [Massacre]), c. 1933
Etching and drypoint on
BFK Rives wove paper
29.8 x 23.4 cm (plate)
Edition of 40
Unsigned; unnumbered
Printer: Atelier Lacourière-
Frélaut, Paris
S. 42
99/770

8.

*Massacre*, c. 1933
Etching on BFK Rives wove paper
11.2 x 14.7 cm (image)
21.9 x 30.0 cm (sheet)
Edition of 117
Signed in pencil l.r.,
numbered l.l. *3/100*
Printer: Atelier Lacourière-
Frélaut, Paris
S. 43
99/771

9.

*Untitled*, 1933
Etching on Japon Impérial wove paper
19.5 x 14.9 cm
Thérèse Aubray, *Battements*(Paris:
Cahiers Libres, 1933)
Copy 16/35
Signed in ink by the artist and author
Printer: Lacourière, Paris
S. 44 (frontispiece); S. & C. 8
99/772

10.

*Sueur de sang* (Sweating Blood), 1933
Etching on Japon Impérial wove paper
23.7 x 17.9 cm (plate)
37.9 x 28.0 cm (sheet)
Pierre Jean Jouve, *Sueur de sang*
(Paris: Cahiers Libres, 1933)
Edition: 22 from 1972 tirage
Unsigned; unnumbered
Printer: Lacourière, Paris, 1972
S. 45; S. & C. 9
99/774

11.

*Orphée* (Orpheus), c. 1933
Etching and drypoint on
BFK Rives wove paper
29.7 x 23.6 cm (plate)
41.1 x 31.1 (sheet)
Edition: 50
Unsigned; unnumbered
Printer: Atelier Lacourière-
Frélaut, Paris, 1972
S. 46
99/775

12 a.

*Mithra*, 1936
Etching in sanguine on Arches wove paper
29.5 x 24.8 cm
S. 48 (pl. I); S. & C. 11
99/856.1

12 b.

*Orphée* (Orpheus), 1936
Etching in sanguine on Arches wove paper
28.0 x 23.4 cm
S. 49 (pl. II); S. & C. 11
99/856.2

12 c.

*Le crucifié* (The Crucified One), 1936
Etching in sanguine on Arches wove paper
31.6 x 24.6 cm
S. 50 (pl. III); S. & C. 11
99/856.3

12 d.

*Minotaure* (Minotaur), 1936
Etching in sanguine on Arches wove paper
31.0 x 21.8 cm
S. 51 (pl. IV); S. & C. 11
99/856.4

12 e.

*Osiris*, c. 1933
Etching in sanguine on Arches wove paper
30.9 x 24.5 cm
Georges Bataille, *Sacrifices*
(Paris: Guy Lévis Mano, 1936)
Copy 37/60 (less than 60 printed)
Unsigned
Printer: J.-J. Taneur, Paris, 1936
S. 52 (pl. V); S. & C. 11
99/856.5

13.

*Orphée* (Orpheus), c. 1933
Etching, drypoint and aquatint
on Arches wove paper
17.5 x 21.5 cm (image)
29.3 x 37.0 cm (sheet)
Edition of 10
Signed in pencil l.r.; numbered l.l. *2/10*
Printer: La Tradition, Paris, 1934
S. 53
99/777

14.

*Diomède* (Diomedes), c. 1933
Etching and drypoint on
Arches wove paper
30.1 x 38.8 cm (sheet)
Edition of 10
Signed in pencil l.r., numbered l.l. *7/10*
Printer: La Tradition, Paris, 1934
S. 54
99/778

15.

*Têtes de chevaux* (Horses' Heads), c. 1933
Etching on BFK Rives wove paper
29.8 x 24.0 cm (plate)
54.4 x 43.9 cm (sheet)
Edition of 10
Signed in pencil l.r., numbered l.l. *4/10*
Printer: La Tradition, Paris, 1934
S. 55
99/779

16.

*Ondine* (Water Sprite), c. 1933
Etching on BFK Rives wove paper
32.7 x 26.8 cm (plate)
52.1 x 42.2 (sheet)
Edition of 10
Signed in pencil l.r., numbered l.l. *8/10*
Printer: La Tradition, Paris, 1934
S. 57
99/780

17.

*La pieuvre* (The Octopus), c. 1933
Etching on Arches wove paper
21.0 x 14.2 cm (plate)
39.4 x 30.2 (sheet)
Edition of 10
Signed in pencil l.r., numbered l.l. *1/10*
Printer: La Tradition, Paris, 1934
S. 58
99/781

18.

*Le champ rouge* (The Red Field), 1934
Oil on canvas
33.0 x 41.0 cm
Signed l.l.
Collection Allan and Sondra Gotlieb

19.

*Les gorgones* (The Gorgons), 1934
Etching, drypoint and aquatint in
green on BFK Rives wove paper
43.9 x 53.0 cm
Edition of 10
Signed in pencil l.r., numbered l.l. *7/10*
Printer: La Tradition, Paris, 1934
S. 61
99/782

20.

*L'Espagne assassinée*
(Murdered Spain), 1938
Etching on Montval laid paper
8.0 x 10.9 cm (image)
22.4 x 16.5 (sheet)
From the album *Solidarité* (Paris:
Published by the contributors, 1938);
with a poem by Paul Éluard from
the edition of 15 numbered
HCI-XV, total edition 165
Signed in pencil l.r.,
numbered l.l. *H.C. IX*
Printer: Atelier 17, Paris
S. 65; S. & C. 12
99/783

21.

*Trois métamorphoses*
(Three Metamorphoses), 1939
Pen and black ink on wove paper
29.8 x 21.8 cm
Signed in ink l.r. *AM 39*
Art Gallery of Ontario
Gift of Allan and Sondra Gotlieb, 1995
95/470

22.

*La légende du maïs*
(Legend of the Maize), 1942
Watercolour and gouache on wove paper
56.2 x 76.3 cm
Signed in pencil l.l. and dated *1942*
99/784

23.

*Emblème* (Emblem), 1942
Soft-ground etching, drypoint and
aquatint in green on Cranach wove paper
24.0 x 22.3 cm (plate)
46.8 x 36.6 cm (sheet)
Signed in pencil ll., numbered l.r. *20/30*
André Masson, *Mythology of Being* (New York:
Wittenborn and Company, 1942)
Copy 20/30
Printer: Atelier 17, New York
S. 82; S. & C. 14
99/785

24.

*Le crabe de terre* (Earth Crab), 1942
Etching, engraving and drypoint on
Cranach wove paper
38.3 x 32.1 cm (sheet)
Edition of 15; 1st state
Signed in pencil l.l., annotated
at l.r. *1er état* and numbered *2/15*
Printer: Atelier 17, New York
S. 83
99/786

25.

*Le génie de l'espèce*

(The Genius of the Species), 1942

Drypoint and engraving in black

on Cranach wove paper

36.7 x 27.4 cm (plate)

50.0 x 38.3 cm (sheet)

Signed in pencil l.r., inscribed

in pencil l.l. *ETAT 1*

Inscribed in pencil l.r. *Essai noir*

*1er état tiré le 3 Fevrier 1942*

Printer: Atelier 17, New York

S. 84

99/787

26.

*Le génie de l'espèce*

(The Genius of the Species), 1942

Drypoint and engraving in sanguine

on Cranach wove paper

36.7 x 27.4 cm (image)

54.4 x 38.1 cm (sheet)

Edition of 30

Signed in pencil l.l., numbered l.r. *16/30*

Printer: Atelier 17, New York

S. 84

99/788

27.

*Le génie de l'espèce*

(The Genius of the Species), 1942

Drypoint and engraving in black

on Cranach wove paper

50.5 x 38.2 cm (sheet)

Edition of 30

Signed in ink l.l., numbered l.r. *25/30*

Printer: Atelier 17, New York

S. 84

99/789

28.

*Les fruits de l'abîme*

(The Fruits of the Abyss), 1942

Soft-ground etching on Umbria wove paper

30.1 x 20.1 cm (plate)

42.8 x 30.4 cm (sheet)

From the album to support the review *VVV*

(New York: Privately published, 1942)

Edition of 20 (approximately)

Signed in pencil l.l. and dated l.r. *42*

Printer: Kurt Seligmann, New York

S. 85; S. & C. 15

99/790

29.

*Petit génie du blé*

(Spirit of the Wheat), 1942

Soft-ground etching and drypoint

on Cranach wove paper

49.2 x 36.4 cm (sheet)

Edition of 20

Signed in pencil l.l., numbered l.r. *12/20*

Printer: Atelier 17, New York

S. 86

99/791

30.

*Signes* (Signs), 1942

Soft-ground etching, drypoint and

etching on Cranach wove paper

19.8 x 15.0 cm (plate)

25.8 x 20.7 cm (sheet)

André Masson, *Anatomy of My Universe*

(New York: Curt Valentin, 1943)

Edition of 30

Signed in pencil l.l.

Printer: Atelier 17, New York

S. 89; S. & C. 16

99/792

31.

*Rêve d'un futur désert*

(Dream of a Future Desert), 1942

Etching and drypoint on wove paper

47.9 x 62.8 cm (image)

63.9 x 76.8 cm (sheet)

Edition of 20 (approximately), 1st state

Signed in pencil l.l., numbered l.r. *10/35*

(only 20 pulled)

Printer: Atelier 17, New York

S. 90

99/793

32.

*Nocturne*, 1944

Soft-ground etching on Swedish

handmade wove paper

20.0 x 15.0 cm (plate)

28.1 x 22.6 cm (sheet)

André Masson, *Nocturnal Notebook*

(New York: Curt Valentin, 1944)

Edition of 50 on rag

Copy 49/50

Signed in maroon ink l.l.,

numbered l.r. *49/50*

Printer: Atelier 17, New York

S. 91; S. & C. 17

99/794

33.

*Improvisation*, 1945

Engraving and aquatint on wove paper

19.8 x 14.9 cm (plate)

32.0 x 25.2 cm (sheet)

Edition of 30

Signed in pencil l.r., numbered l.l. *30/30*

Printer: Atelier 17, New York

S. 94

99/795

34.
*Rodéo* (Rodeo), 1945
Soft-ground etching on wove paper
32.5 x 51.1 cm (sheet)
Edition of 50
Signed in pencil l.r., numbered l.l. *38/50*
Printer: Atelier 17, New York
S. 97
99/796

35.
*Résurrection* (Resurrection), 1945
Lithograph on BFK Rives wove paper
35.7 x 28.4 cm
Edition of 30
Signed in pencil l.r., numbered l.l. *6/30*
Printer: George Miller, New York
S. 102
99/797

36.
*Portrait de Georges Duthuit*
(Portrait of Georges Duthuit), 1945
Lithograph on Marais wove paper
33.0 x 25.3 cm (sheet)
Georges Duthuit, *La serpent dans la galère*
(New York: Curt Valentin, 1945)
Copy 54/75
Signed in pencil l.r. by the author
Printer: George Miller, New York
S. 111; S. & C. 18
99/798

37.
*Le plus cruel de tous les animaux*
(The Most Cruel of Animals), 1945
Lithograph on Strathmore wove paper
40.5 x 30.5 cm
André Masson, *Bestiaire*
(New York: Curt Valentin, 1946)
Copy 56/135
Unsigned
Printer: George Miller, New York, 1946
S. 113 (pl. II); S. & C. 19
99/799

38.
*La terre ensemencée*
(The Seeded Earth), 1945
Transfer lithograph on Marais wove paper
32.7 x 25.4 cm
Edition of 30
Signed in pencil l.r., numbered l.l. *17/30*
Printer: Desjobert, Paris
S. 125
99/800

39.
*Untitled*, 1948
Lithograph on Marais wove paper
34.3 x 26.2 cm.
Samuel Taylor Coleridge, *Le dit du vieux marin,
Christabel et Koubla Khan* (Paris:
Collections Vrille, 1948)
Copy 27/220
Unsigned
Printer: Desjobert, Paris
S. 128 (p. 27); S. & C. 23
99/801.3

40.
*Portrait d'Emily Brontë*
(Portrait of Emily Brontë), 1946
Lithograph on Marais wove paper
33.0 x 25.0 cm
Edition of 30
Signed in pencil l.r., numbered l.l. *19/30*
Printer: Desjobert, Paris
S. 139
99/802

41.
*Portrait de Daniel-Henry Kahnweiler*
(Portrait of Daniel-Henry Kahnweiler),
1946
Lithograph on Arches wove paper
45.5 x 32.0 cm
Edition of 30
Signed in pencil l.r., numbered l.l. *11/30*
Printer: Desjobert, Paris
S. 143
99/803

42.
*Hespéride* (Hesperide), 1947
Colour lithograph on BFK Rives wove paper
65.0 x 50.7 cm
Edition of 75
Signed in pencil l.r., numbered l.l. *55/75*
Printer: Desjobert, Paris
S. 220
99/804

43.
*Arbres enlacés*
(Intertwining Trees), 1941? 1946?
Drypoint on BFK Rives wove paper
66.2 x 50.0 cm (sheet)
Edition of 30
Signed in pencil l.r., numbered l.l. *15/30*
Printer: Crommelynck & Dutrou,
Paris, 1958
S. 225
99/805

44.
*Rapt* (Abduction), 1941? 1946?
Drypoint on Japon ancien wove paper
30.8 x 40.6 cm (image)
50.1 x 66.5 cm (sheet)
Edition of 10
Signed in pencil l.r., numbered l.l. *5/10*
Printer: Crommelynck & Dutrou,
Paris, 1958
S. 226
99/806

45.
*Êtres enchevêtrés* (Entangled Beings),
1941? 1946?
Drypoint on Japon ancien wove paper
65.2 x 50.5 cm (sheet)
Edition of 30
Signed in pencil l.r., numbered l.l. *8/30*
Printer: Crommelynck & Dutrou,
Paris, 1958
S. 227
99/807

46.

*Penthésilée* (Penthesilea), 1946

Drypoint on Arches wove paper

50.6 x 66.7 cm (sheet) (large version)

Edition of 30

Signed in pencil l.l., numbered l.r. *15/30*

Printer: Lacourière, Paris, 1955

S. 228

99/808

47.

*Penthésilée* (Penthesilea), 1946

Drypoint on Arches wove paper

33.1 x 25.2 cm (sheet) (small version)

Edition of 25

Signed in pencil l.l., numbered l.r. *8/25*

Printer: Lacourière, Paris, 1955

S. 229

99/809

48.

*Métamorphoses*

(Metamorphoses), c. 1946 (1961)

Drypoint and aquatint on Ingres laid paper

(reproduction from black plate

with a gold aquatint plate added,

c. 1955, signed 1980s)

32.5 x 44.1 cm (sheet)

Edition: 50 of 2nd state printed 1961

Signed in pencil l.r., numbered l.l. *48/50*

Printer: Atelier Crommelynck

Frères, Paris, 1961

S. 230

99/810

49.

*L'œuf cosmique*

(The Cosmic Egg), c. 1946 (1961)

Drypoint and aquatint, printed

in colours on wove paper

25.2 x 20.5 cm (plate)

38.0 x 28.4 cm (sheet)

Edition: 2nd state 1961 with

aquatint in black and colours

Signed in pencil l.r., numbered l.l. *30/50*

Printer: Atelier Crommelynck

Frères, Paris, 1961

S. 232

99/811

50.

*Caprice villageois*

(Village Fantasy), c. 1946 (1958)

Colour drypoint on BFK Rives wove paper

50.0 x 33.0 cm (sheet)

2nd state 1958

Signed in pencil l.r., numbered l.l. *11/30*

Printer: Crommelynck & Dutrou, Paris,

1958

S. 233

99/812

51.

*Totem*, c. 1946

Drypoint on Arches wove paper

27.8 x 17.8 cm (plate)

38.0 x 28.8 cm (sheet)

Edition of 30

Signed in pencil l.r., numbered l.l. *10/30*

Printer: Lacourière, Paris, 1959

S. 234

99/813

52.

*Femme poursuivie* (Pursued Woman),

c. 1946

Drypoint on BFK Rives wove paper

50.0 x 33.1 cm (sheet)

Edition of 30

Signed in pencil l.r., numbered l.l. *12/30*

Printer: Crommelynck & Dutrou,

Paris, 1958

S. 235

99/814

53.

*Fantaisie animale*

(Animal Fantasy), c. 1946 (1955)

Etching and drypoint on

Arches wove paper

33.5 x 25.3 cm (sheet)

Edition of 20

Signed in pencil l.l., numbered l.r. *10/20*

Printer: Lacourière, Paris, 1955

S. 236

99/815

54.

*Sisyphe* (Sisyphus) (1st state), 1946

Drypoint on Marais wove paper

56.2 x 76.6 cm (sheet)

Edition of 10

Signed in pencil l.r., annotated

l.l. *1$^{er}$ état* and numbered *2/10*

Printer: Lacourière, Paris

S. 238

99/816

55.

*Sisyphe* (Sisyphus) (2nd state), 1946

Drypoint and aquatint on wove paper

56.2 x 76.2 cm (sheet)

Edition of 20

Signed in pencil l.r., numbered l.l. *6/20*

Printer: Lacourière, Paris, 1947

S. 239

01/6

56.

*Femme attaquée par des oiseaux*
(Woman Attacked by Birds), 1947
Drypoint on Marais wove paper
42.2 x 32.9 cm (sheet)
From the portfolio *Brunidor Portfolio Numéro 2*
(Paris: Robert Altmann, 1947–1952)
Edition of 108; 1st state
Signed in pencil l.r., numbered l.l. *67/80*
Printer: Lacourière, Paris
S. 245; S. & C. 34
99/817

57.

*Femme attaquée par des oiseaux*
(Woman Attacked by Birds), 1956
Drypoint and aquatint on
Arches wove paper
57.2 x 38.3 cm (sheet)
Edition of 30; 2nd state
Signed in pencil l.r., numbered l.l. *5/30*
Printer: Lacourière, Paris
S. 245; S. & C. 34
99/818

58.

*Léda* (Leda), 1947
Drypoint on Marais wove paper
56.5 x 42.2 cm (sheet)
Edition of 30
Signed in pencil l.r., inscribed
in pencil l.l. *Epreuve d'artiste*
Printer: Lacourière, Paris
S. 248
99/819

59.

*Untitled*, 1949
Aquatint on Marais wove paper
40.0 x 30.0 cm
André Malraux, *Les conquérants*
(Paris: Albert Skira, 1949)
Copy 74/125
Signed by the artist and author,
initialled by the publisher
Printer: Lacourière, Paris
S. 250 (frontispiece); S. & C. 27
99/820.1

60.

*La nourrice des oiseaux*
(Mother to the Birds), 1947
Etching and aquatint, printed
in colours on wove paper
54.3 x 39.2 cm (plate)
66.5 x 50.6 cm (sheet)
Edition of 60 numbered copies
Signed in pencil l.l., numbered l.r. *35/60*
Printer: Lacourière, Paris
Passeron 12
99/821

61.

*Les grenouilles* (The Frogs), c. 1948
Colour lithograph on B.F.K.
Rives wove paper
50.5 x 65.4 cm
Edition of 75
Signed in pencil l.r.; numbered l.l.: *54/75*
Printer: Desjobert
S. 221
99/822

62.

*Nu vert* (Green Nude), 1950
lithograph on Chine collé
on Arches wove paper
38.4 x 28.2 cm
Edition of 40
Signed in pencil l.l., numbered l.l. *27/40*
Printer: Léo Marchutz, Aix-en-Provence
99/823

63.

*Cascatelles* (Cascades), 1950
Lithograph on Arches wove paper
32.5 x 25.0 c
André Masson, *Carnet de Croquis*
(Paris: Galerie Louise Leiris, 1950)
Copy 34/50
Signed and initialled in pencil l.l.,
numbered l.l. *34/50*
Printer: Léo Marchutz, Aix-en-Provence
S. & C. 29 (pl. 5)
99/824.6

64.

*Portiques battus par la mer*
(Weathered Porticos), 1951
Colour lithograph on Arches wove paper
63.6 x 45.4 cm
Edition of 30
Signed in pencil l.l., numbered l.r. *20/30*
Printer: Léo Marchutz, Aix-en-Provence
Passeron 23
99/825

65.

*Untitled*, 1951
Lithograph in colour on chine
collé on Arches wove paper
38.1 x 28.3 cm
Michel Leiris, *Toro* (Paris: Galerie
Louise Leiris, 1951)
Copy 2/5
Initialled in pencil l.l.
Printer: Léo Marchutz, Aix-en-Provence
S. & C. 31 (pl. 2)
99/826.3

66.

*Tête de paysanne*
(Head of a Peasant), c. 1952
Lithograph on Chine collé
on Arches wove paper
56.4 x 38.2 cm
Edition of 40
Signed in pencil l.l.; numbered l.r. *38/40*
Printer: Léo Marchutz, Aix-en-Provence
99/827

67. a.

*Statue de Colleoni: la nuit*

(Statue of Colleoni: Nighttime), 1952
Colour lithograph on chine
collé on Arches wove paper
52.5 x 37.8 cm
Initialled by the artist l.r.
S. & C. 33 (pl. IX)
99/828.23

67. b

*Bassin de Saint-Marc*

(Bacino San Marco), 1952
Colour lithograph on chine
collé on Arches wove paper
52.5 x 37.8 cm
André Masson, *Voyage à Venise*
(Paris: Galerie Louise Leiris, 1952)
Copy 44/50
Initialled by the artist l.r.
Printer: Léo Marchutz, Aix-en-Provence
S. & C. 33 (pl. XXIV)
99/828.38

68.

*Au portique d'Octavie*

(Portico of Octavia), 1953
Colour lithograph on chine
collé on Arches wove paper
63.5 x 45.5 cm
Edition of 30
Signed in pencil l.l.; numbered l.r. *26/30*
Printer: Léo Marchutz, Aix-en-Provence
99/829

69.

*Au théâtre de Marcellus*

(Theatre of Marcellus), 1953
Colour lithograph on Arches wove paper
50.2 x 65.6 cm
Edition of 30
Signed in pencil l.r.; numbered l.r. *29/30*
Printer: Léo Marchutz, Aix-en-Provence
Passeron 24
99/830

70.

*Un couple sur une feuille*

(Couple on a Leaf), 1954
Etching and aquatint, printed in
colours on BFK Rives wove paper
30.8 x 25.7 cm (plate)
49.8 x 37.2 cm (sheet)
Edition of 30 numbered copies
Signed and dated in pencil l.l.,
numbered l.r. *28/30*
Printer: Atelier Lacourière-Frélaut, Paris
Passeron 25
99/831

71.

*L'oiseau amoureux*

(The Amorous Bird), 1957
Colour drypoint and aquatint on wove paper
21.0 x 17.3 cm (plate)
44.3 x 32.8 cm (sheet)
Edition of 30
Signed in pencil l.r.; numbered l.l. *12/30*
Printer: Crommelynck & Dutrou, Paris
99/832

72.

*Les oiseaux sacrifiés*

(The Sacrificed Birds), 1954
Etching and aquatint, printed
in colours on wove paper
30.8 x 25.7 cm (plate)
50.4 x 38.3 cm (sheet)
Edition of 30
Signed in pencil l.r. and inscribed l.l.: *E.A.*
Printer: Atelier Lacourière-Frélaut, Paris
Passeron 26
99/833

73.

*Baigneuse à l'aube*

(Bather at Dawn), 1955
Colour aquatint on Arches wove paper
30.8 x 41.2 cm (plate)
50.4 x 66.2 cm (sheet)
Edition of 50
Unsigned; unnumbered
Printer: Atelier Lacourière-Frélaut, Paris
99/834

74.

*Mante* (Mantis), 1955
Colour etching and aquatint
on Arches wove paper
47.3 x 20.8 cm (plate)
63.5 x 45.5 cm (sheet)
Edition of 50 numbered copies
Signed in pencil l.l., numbered l.r. *40/50*
Printer: Atelier Lacourière-Frélaut, Paris
99/835

75.

*Chrysalides* (Chrysalises), 1955
Colour aquatint on wove paper
34.7 x 27.6 cm (plate)
50.2 x 38.2 cm (sheet)
Proof print for edition of
30 numbered copies
Signed in pencil l.r., inscribed l.l.
*Ep. d'artiste*
Printer: Atelier Lacourière-Frélaut, Paris
99/836

76.

*Oiseau cosmique* (Cosmic Bird), 1955
Colour aquatint on B.F.K.
Rives wove paper
32.7 x 42.5 cm (plate)
49.8 x 65.5 cm (sheet)
Bon à tirer for edition of 50
Inscribed in pencil l.r. *Bon à tirer/A.M*
Printer: Atelier Lacourière-Frélaut, Paris
99/837

77.
*Raillerie* (Mockery), 1956
Etching and aquatint on Auvergne du
Moulin Richard-de-Bas wove paper
43.7 x 32.3 cm (plate)
Jean Paulhan, *Les Hain-Teny* (Paris: Les
Bibliophiles de l'Union française, 1956)
Copy 11/100
Signed in pencil on *achevé d'imprimeur*
by artist, author and president
of the book club
Printer: Atelier Lacourière-Frélaut, Paris
S. & C. 36
99/838.19

78.
*Message de mai* (May Message), 1957
Lithograph on Arches wove paper
65.5 x 51.0 cm
Edition of 50
Signed in pencil l.r.; numbered l.l. *29/50*
Printer: Mourlot Frères, Paris
Passeron 36
99/839

79.
*La femme élémentaire*
(The Elementary Woman), 1957
Colour etching and aquatint
on Rives wove paper
38.2 x 27.8 cm (sheet)
André Masson, *Féminaire* (Paris:
Galerie Louise Leiris, 1957)
Copy 24/50
Signed by artist
Printer: Lacourière, Paris
S. & C. 40 (pl. 1)
99/840.1

80.
*Acteurs chinois* (Chinese Actors), 1957
Etching and aquatint on Arches wove paper
59.6 x 44.5 cm (image)
76.4 x 57.0 cm (sheet)
Edition of 35
Signed in pencil l.r.; numbered l.l. *6/35*
Printer: Atelier Lacourière-Frélaut, Paris
Passeron 37
99/841

81.
*Untitled*, 1957
Colour lithograph on Arches wove paper
16.6 x 16.7 cm
André Masson, *André Masson, Peintures récentes et
anciennes* (Paris: Galerie Louise Leiris, 1957)
Edition: unnumbered regular edition
Printer: Mourlot Frères, Paris
S. & C. 41
99/842

82.
*Couple étendu*
(Embracing Couple), 1959
Lithograph on Arches wove paper
50.4 x 66.0 cm
Edition of 50
Signed in pencil l.r.;
numbered l.l. *10/50*
Printer: Mourlot Frères, Paris
99/843

83.
*Jardin de tantale*
(The Garden of Tantalus), 1959
Lithograph on Arches wove paper
50.6 x 66.2 cm
Edition of 50
signed in pencil l.r.; numbered l.l. *17/50*
Printer: Mourlot Frères, Paris
99/844

84.
*Personnages* (Figures), 1960
Colour etching on Japanese wove paper
33.6 x 26.0 cm (plate)
65.9 x 50.8 cm (sheet)
Edition of 10
Signed by artist l.r., numbered
l.l. *1/10* from *Les érophages*
Printer: Atelier Lacourière-Frélaut, Paris
S. & C. 47
99/845

85.
*Untitled*, 1960
Etching and aquatint on Rives wove paper
33.2 x 25.5 cm (plate)
43.8 x 69.9 cm (sheet)
André Maurois, *Les érophages* (Paris:
Les Editions la Passerelle, 1960)
Edition of 146
Signed by the artist, the author
and publisher in blue crayon
Printer: Lacourière-Frélaut, Paris
S. & C. 47 (p. 67)
99.846.13

86.
*Untitled*, 1961
Etching and aquatint on Rives wove paper
39.5 x 30.4 cm
Arthur Rimbaud, *Une saison en enfer*
(Paris: Société Les Cent-Une de
femmes bibliophiles, 1961)
Copy 87/101
Signed by the artist, president and vice
president of publishing society
Printer: Atelier Crommelynck
Frères, Paris
S. & C. 50
99/847.3

87.
*Untitled*, 1962
Etching and aquatint on
Arches wove paper
40.0 x 30.0 cm
André Masson, *Trophées érotiques*
(Paris: Galerie Louise Leiris, 1962)
Copy 18/100
Signed in pencil by the artist
Printer: Atelier Crommelynck
Frères, Paris
S. & C. 52 (frontispiece)
99/848.2

88.
*Untitled*, 1962
Colour lithograph on wove paper
16.6 x 16.6 cm
*André Masson, Peintures 1960–1961*
(Paris: Galerie Louise Leiris, 1962)
Edition: unnumbered regular edition
Printer: Mourlot Frères, Paris
S. & C. 53
99/849

89.
*Sacrifice solaire* (Solar Sacrifice), 1965
Etching and aquatint on wove paper
20.8 x 26.5 cm (plate)
31.8 x 37.7 cm (sheet)
Edition of 50
Signed in pencil l.r.,
numbered l.l. *3/50*
Printer: Atelier Crommelynck
Frères, Paris
99/850

90.
*Le génie de la fertilité*
(Spirit of Fertility), 1969
Colour lithograph on wove paper
31.2 x 24.3 cm
Patrick Waldberg et al, *XXᵉ Siècle.*
*Panorama 69* (Paris: Les grandes
expositions dans les Musées et dans les
Galeries en France et à l'Etranger, 1969)
Edition: unnumbered regular edition
Unsigned
Printer: Mourlot Frères, Paris
S. & C. 82
99/851

91.
*Untitled*, 1971
Colour lithograph on Arches wove paper
30.8 x 24.6 cm
Michel Leiris, *André Masson. Massacres et autres*
*dessins* (Paris: Hermann, éditeurs des
sciences et des arts, 1971)
Edition of 120
Signed in pencil l.r., numbered l.l. *83/120*
Printer: Mourlot Frères, Paris
S. & C. 87
99/852

92.
*Trophées* (Trophies), 1972
Colour etching and aquatint
on wove paper
26.7 x 20.8 cm (plate)
41.0 x 33.2 cm (sheet)
Edition of 50
Signed in pencil l.r.; numbered l.l. *3/50*
Printer: Atelier Crommelynck
Frères, Paris
99/853

93.
*Oaristys*, 1972
Colour lithograph on wove paper
35.3 x 29.1 cm
Roger Passeron, *André Masson. Gravures*
*1924–1972* (Fribourg: Office
du Livre, 1973)
Copy F323/F700
Unsigned
Printer: Mourlot Frères, Paris
S. & C. 95 (p. 2)
99/854.1

94.
*Untitled*, 1974
Etching and aquatint on
Arches wove paper
48.0 x 62.6 cm (plate)
56.8 x 75.7 cm (sheet)
*Die Welt des Klassizismus* (Berlin:
Propyläen Verlag, 1974)
Edition of 80
Signed in pencil l.r.;
numbered l.l. *79/80*
Printer: Atelier Crommelynck
Frères, Paris
S. & C. 101
99/855

# SELECTED BIBLIOGRAPHY

Ades, Dawn. *Dada and Surrealism Reviewed*. Exhibition catalogue. London: Hayward Gallery, 1978.

Ades, Dawn. *Masson*. Barcelona: Ediciones Polígrafa, 1994.

Bosch, Glòria, and Teresa Grandas. *André Masson & Georges Bataille, Complicitats*. Exhibition catalogue. Tossa de Mar: Musée Municipal de Tossa de Mar, 1991.

Breton, André. *Manifestoes of Surrealism*. Translated by Richard Seaver and Helen R. Lane. Ann Arbor: The University of Michigan Press, 1974.

Clébert, Jean-Paul. *Mythologie d'André Masson*. Geneva: Pierre Cailler, 1971.

Duby, Georges. *André Masson: Nature's delirious wisdom*. Exhibition catalogue. Aosta, Italy: Museo Archeologico, 1995.

Hubert, Renée Riese. *Surrealism and the Book*. Berkeley: University of California Press, 1988.

Jeffett, William. "Homage to 45, rue Blomet." *Apollo* no. 127 (March 1988): 189–191.

Jeffett et al. *André Masson: The 1930s*. Exhibition catalogue. St. Petersburg, Florida: Salvador Dali Museum, 1999.

Kaplan, Gilbert, ed. *Surrealist Prints*. New York: Harry N. Abrams, 1997.

Kramer, Hilton. "Masson Remains an Artist Who Is Not Quite There." *New York Times*. 13 June 1976.

Kuthy et al. *Masson: Massaker, Metamorphosen, Mythologien*. Exhibition catalogue. Bern: Kunstmuseum, September– November 1996.

Lahumière, Jean-Claude, and Anne Lahumière. *André Masson: Graveur*. Exhibition catalogue. Paris: Galerie Lahumière, n.d.

Levaillant, Françoise. "Le mythe, dans l'œuvre graphique d'André Masson, au debut des années 30: un problème d'interprétation." *L'Art face à la crise: L'art en Occident 1929–1939*. Travaux 26. Université de Saint-Étienne: Actes/ du 4$^e$ Colloque d'histoire de l'art contemporain, (22–25 March 1979): 111–134.

Levaillant, Françoise. *André Masson: Livres illustrés de gravures originales*. Exhibition catalogue. Asnières-sur-Oise: Centre littéraire, Fondation Royaumont, 1985.

Levaillant, Françoise. *André Masson*. Exhibition catalogue. Nîmes: Musée des Beaux-Arts, 1985.

Masson, André. "A Crisis of the Imaginary." *Horizon* 12 (July 1945): 42–44. Reprint from original text in Masson. "Une crise de l'imaginaire." *Fontaine* no. 35 (1944): 539–542.

Masson, André. "My idea of America…" in "Eleven Europeans in America." *Museum of Modern Art Bulletin* 13, nos. 4–5 (1946): 3–6, 38.

Masson, André. "Color and the lithographer." *The Tiger's Eye* 8 (June 1949): 56–58. Reprinted later in the original French text in Masson, André. *Le plaisir de peindre*. Nice: La Diane française, 1950.

Masson, André. *André Masson Correspondance 1916–1942: Les années surréalistes*. Edited by Françoise Levaillant. Paris: La Manufacture, 1990.

Masson, André. *Le rebelle du surréalisme: écrits*. Edited by Françoise Levaillant. Paris: Hermann, 1994.

Monahan, Laurie. *A Knife Halfway Into Dreams: André Masson, Massacres and Surrealism of the 1930s*. Ph.D. diss., Harvard University, 1997.

Monahan, Laurie. "Masson: The Face of Violence." *Art in America* 88 (July 2000): 76–79; 121–122.

Monahan, Laurie. "Violence in Paradise: André Masson and the *Massacres*." *Art History* (forthcoming).

Passeron, Roger. *André Masson: Gravures 1924–1972*. Fribourg: Office du Livre, 1973.

Passeron, Roger. "André Masson, graveur." *L'œil* no. 317 (December 1981): 54–61.

Passeron, Roger. "Conversations avec André Masson." *L'œil* nos. 426–427 (January–February 1991): 72–77.

Rosenthal, Deborah. "Approaches to André Masson." *Arts Magazine* 50 (June 1976): 62–65.

Rosenthal, Deborah. "Interview with André Masson." *Arts Magazine* 55 (November 1980): 88–94.

Rubin, William. "Notes on Masson and Pollock." *Arts* 34 (November 1959): 36–43.

Rubin, William. *Dada, Surrealism, and Their Heritage*. Exhibition catalogue. New York: The Museum of Modern Art, 1968.

Rubin, William, and Carolyn Lanchner. *André Masson*. Exhibition catalogue. New York: The Museum of Modern Art, 1976.

Saphire, Lawrence. *André Masson: The Complete Graphic Work*. Vol. 1, *Surrealism, 1924–1949*. Yorktown Heights, N.Y.: Blue Moon Press, 1990.

Saphire, Lawrence, and Patrick Cramer. *André Masson: The Illustrated Books: Catalogue Raisonné*. Translated by Gail Mangold-Vine and Christopher Snow. Geneva: Patrick Cramer, 1994.

Sawin, Martica. *André Masson in America 1941–1945*. Exhibition catalogue. New York: Zabriskie Gallery, 1996.

Stoekl, Allan, ed. *Georges Bataille: Visions of Excess: Selected Writings, 1927–1939*. Minneapolis: University of Minnesota Press, 1985.

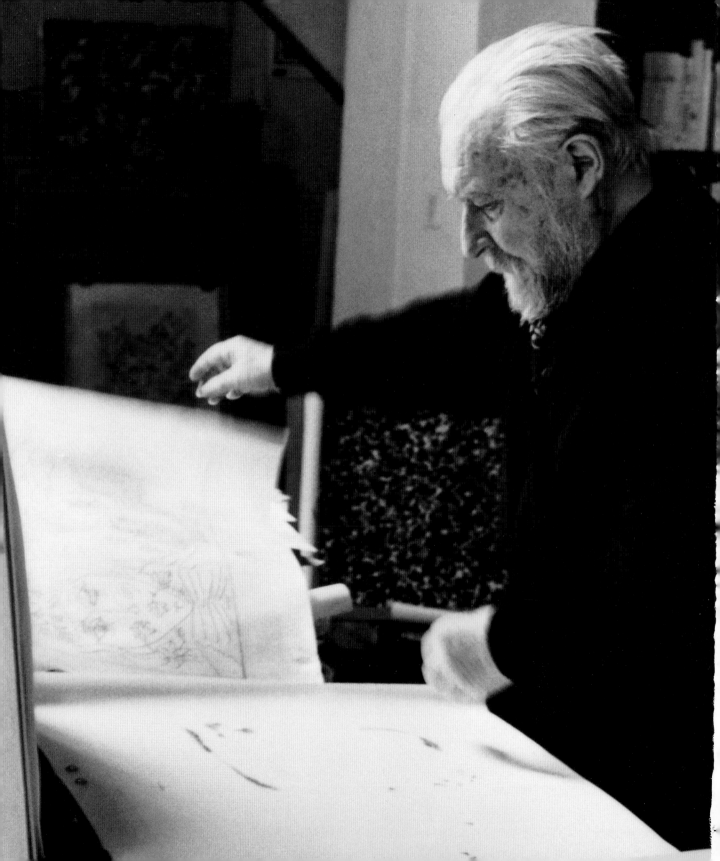